RUNCORN
AT WORK

JEAN & JOHN BRADBURN

AMBERLEY

First published 2019

Amberley Publishing
The Hill, Stroud
Gloucestershire, GL5 4EP

www.amberley-books.com

Copyright © Jean & John Bradburn, 2019

The right of Jean & John Bradburn to be identified as
the Authors of this work has been asserted in accordance
with the Copyrights, Designs and Patents Act 1988.

ISBN 978 1 4456 8105 4 (print)
ISBN 978 1 4456 8106 1 (ebook)

British Library Cataloguing in Publication Data.
A catalogue record for this book is available
from the British Library.

Typesetting by Aura Technology and Software
Services, India. Printed in the UK.

CONTENTS

INTRODUCTION

Until the Romans arrived Cheshire was populated by Ancient Britons. They were Celts and they lived a nomadic lifestyle, but eventually settled to cultivate and to rear cattle. They could spin and weave and use iron tools. They had their own language and it can still be recognised in some Cheshire place names. By AD 45 the Romans were established in the south and legions began to move north. The Romans founded Chester as Deva in the AD 70s in the land of the Celts. They had identified its strategic position – its fine harbour at the highest navigable point on the Dee, a river crossing, and a defendable position. From Chester the road to Warrington passed through Helsby, Frodsham and Daresbury.

The Romans would have explored the possibility of crossing the Mersey at Runcorn and they would have certainly camped on Halton Hill. Remains have been found at Halton Brow and the street names reflect this: Caesar's Close, Roman Close and Centurion Row. The Romans left Britain around AD 410 and the area was left to the deer and wild boar. Nothing much happened until Ethelfleda arrived to protect the Northern border of Mercia.

SAXON CHESHIRE

The Anglo-Saxon kingdom of Mercia was one of the seven kingdoms: Kent, Essex, East Anglia, Wessex, Mercia and Northumbria. The origins of Mercia were based on settlements in the North Midlands. In the seventh century it emerged as one of

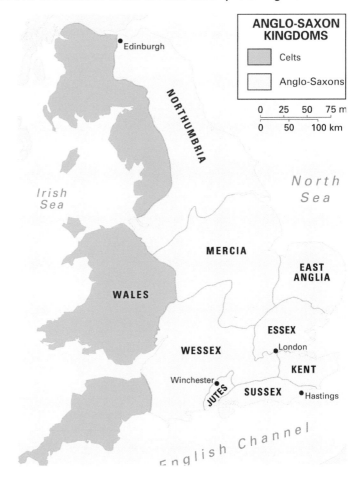

Saxon Britain.

the three most powerful kingdoms in England along with Wessex and Northumbria. The kingdoms were under constant threat from Norse men and Danes. In 865 a great army of Vikings conquered East Anglia, Northumbria and Mercia. The advancing Scandinavians were stemmed by Alfred the Great in 878 at the Battle of Edington.

It is surprising that Ethelfleda, or Aethelflaed, 'Lady of the Mercians', has rather been forgotten in history. She was a warrior and a woman who secured our kingdom and laid the foundations for a united England. She was the daughter of Alfred the Great and was born during the fight for survival against Viking invaders. She grew up in a realm teetering on the brink of disaster. She was one of only a handful of Anglo-Saxon women to wield power and maintain the loyalty and devotion of her forces until her death. After the death of her husband, Aethelred, 'Lord of Mercia', she was recognised as the ruler of the kingdom. She did not remarry. This would have given control to a new husband and as a celibate woman she would be considered more manly and therefore she would be taken more seriously.

After their father's death, she and her brother, Edward the Elder, were determined to throw the Danes out of the country. As the Mercian register makes clear, Ethelfleda shared in her brother's effort to reconquer the Danelaw. The first attack came in 909, when

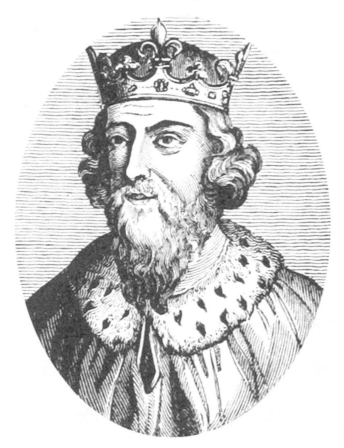

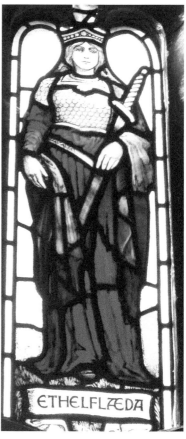

Above left: King Alfred.

Above right: Ethelfleda.

the Anglo-Saxon Chronicle records that Edward sent a combined army of West Saxons and Mercians into the territory of the northern Danish army.

King Alfred had started the construction of fortified sites (burhs) in Wessex, but Ethelfleda extended this system into Mercia when the Vikings were threatening Cheshire. They served the dual purpose of consolidating the defence of English territory and providing bases for attacks on Viking-occupied areas. She well understood that these forts should be built in strategic positions, on hills or river estuaries. In 914 she reinforced the Iron Age fort on Eddisbury hill and the following year she built the fort at Rumcofa (Runcorn). Here she founded a church dedicated to Saint Bertelin. The fort was a simple ditch and wooden rampart and there is no evidence that it was ever called upon to defend the site against the Danes. The structure slowly disappeared and was only discovered when the railway bridge was built in 1868.

Ethelfleda died in 918 in Tamworth. Her legacy has often been forgotten but there is no doubt that she will not be forgotten in Runcorn. Her only daughter never married and Edward then claimed his sister's kingdom and completed the subjugation of the Danes and almost all of England came under his control.

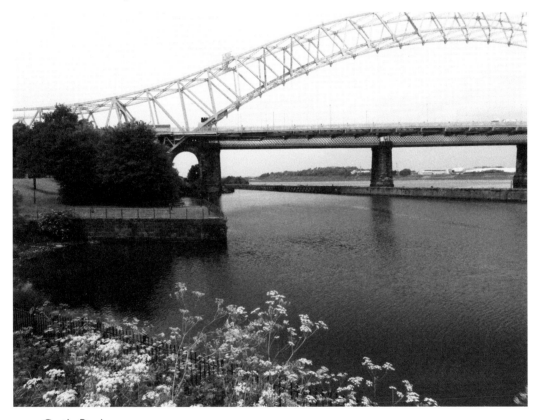

Castle Rock.

NORMAN CHESHIRE

R uncorn remained a remote and largely isolated place until the Normans arrived. Runcorn is not mentioned in the Domesday Book and it is assumed it was included in Halton. The barony of Halton was given by Hugh Lupus, Earl of Chester, to his cousin Nigel. The population of Runcorn was increasing and the river gave employment to many and the land was productive. Nigel needed to protect the area from attack and built his castle on the prominent Halton Hill in 1071. It was a typical motte-and-bailey castle and no remains of this original fortification exist. The original building was replaced with the current sandstone castle in the thirteenth century.

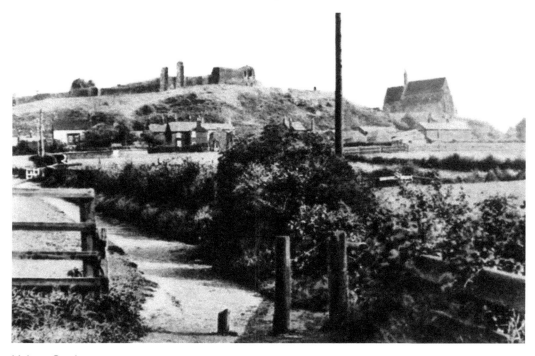

Halton Castle.

There is a belief that in 1207, King John visited and donated £5 towards the upkeep of its chapel. Edward II visited the castle and was there for three days in November 1323, during which time he also visited Norton Priory.

When the 15th Baron, Henry Bolingbroke, ascended the throne as King Henry IV in 1399, the castle became the property of the Duchy of Lancaster. The Royalists garrisoned the castle in the Civil War. It was besieged by Parliamentary forces under Sir William Brereton in 1643, and the Royalists eventually surrendered after several weeks. There was a second siege in 1644 but, as the fortunes of the Royalists declined elsewhere, they withdrew from Halton and the Parliamentarians under Sir William Brereton reoccupied the castle. The castle was later used as a courthouse but has been in ruins for many years.

EARLY TRANSPORT: THE FERRY

I n 1115 William FitzNigel founded an Augustine priory at Runcorn, thus increasing the town's status. Pilgrims now began to visit Runcorn and crossing the river became essential. The Barons kept a boat to cross the river but ordinary folk had to swim or wait for low tide and walk, which was muddy and dangerous. The first ferry was established around 1178 by John FitzRichard. The first charter is that of Richard De Mora. It bears a seal of green wax with the trefoil signed 'Sigillum Ricardi de la Mor.'

Originally the ferry crossed from The Boat House pool near the junction of Bridge Street and Mersey Street until it had to move to Castle Rock as the creek was filled in with the coming of the canals. Crossing the river by ferry was not a reliable way to cross. Travellers were landed with their luggage on the beach – there was no slipway. The

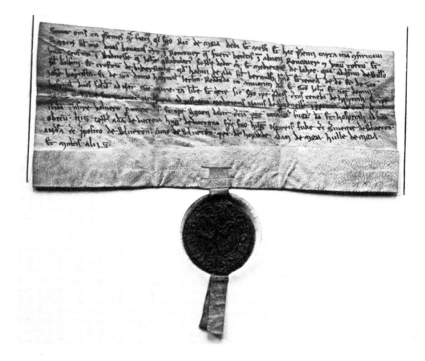

Ferry
Charter.

ferrymen were not always on duty and newspaper articles contained many complaints. The price was also questioned. It was 2 pence to cross and 3 pence for a return trip. A coffin with corpse and six bearers cost 3s 0d. The service was advertised to run from 6 a.m. to 8 p.m. (weather permitting), but this was often not the case. Eventually a waiting room and booking office were provided. The coming of the railway bridge in 1868 reduced traffic and the opening of the Transporter saw the end of the ferry.

Runcorn sits on the edge of the Mersey Estuary so seafaring was inevitable, but the coming of the canals changed the town's future forever. Lacemaking was a traditional cottage industry in Runcorn. This could have originated through the pilgrims passing through Runcorn, as lace was used by clergy as part of vestments in religious ceremonies.

Cheshire is renowned for its dairy farming and salt workings but Runcorn's story included canals, soap making, quarrying, tanneries and shipbuilding all before we consider the chemical industry.

Runcorn remained a backwater for many years, with only the ferry bringing visitors to the area, including pilgrims to Norton Priory. The population was small with only a few cottages near to the Sprinch Brook and by the river at Mount Pleasant. There were few houses of distinction other than the home of the Wright family near Delph Bridge and another old hall standing where Wilsons Hotel stands today. Bert Starkey tells us that the Royal Hotel was then a tiny thatched pub called the White Hart. The parish church stood out as the building of distinction.

Lacemaker.

Left: Lacemaker.

Below: Saxton's map, 1577.

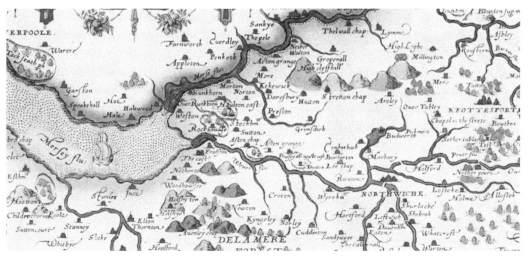

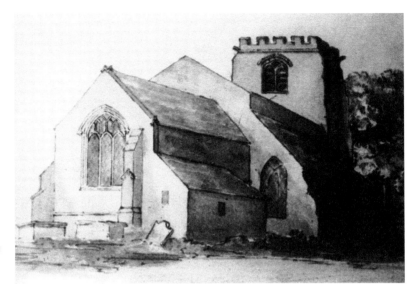

Medieval parish church.

Right: Mount Pleasant.

Below: Norton Priory.

THE BRIDGEWATER CANAL

So the town would remain until James Brindley looked at the map and chose Runcorn as his gateway to the sea. The canal opened up the countryside to efficient transport of goods and resulted in a huge increase of trade and population and brought prosperity to the town.

The Duke of Bridgewater built himself a fine house, which we can still see today – Bridgewater House. He visited Runcorn regularly and used his house to accommodate his workforce.

The building of the ten locks, at Runcorn, were the wonder of their time and put Runcorn on the world map and gave work to hundreds. On New Year's Day 1773 600 workers were entertained by the side of the locks with roast beef and good liquor and toasts were made to 'prosperity to the town of Runcorn'. It was not just navigators who found work; the fine sandstone on Runcorn Hill gave work to quarrymen. By

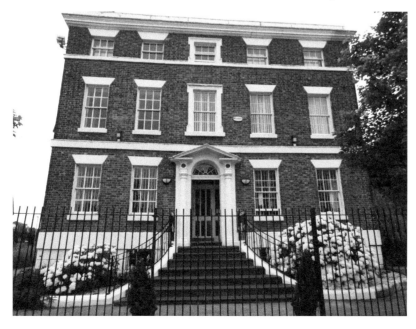

Bridgewater House.

1785 the line of locks ended in a tidal basin – the beginnings of the Port of Runcorn, which became an important location in the canal system. It became a transshipment point for coastal vessels. Sheds built next to the docks allowed for storage of cargo until such time as it could be loaded onto the smaller barges for onward transportation by canal. Runcorn also served as an entry point for the duke's flats coming from his dock at Liverpool. These flats could sail directly into the Bridgewater Canal and waterways network because of their size.

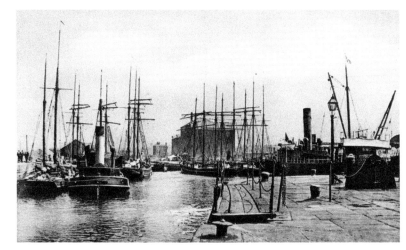

Right: Runcorn Docks.

Below: Runcorn, 1782.

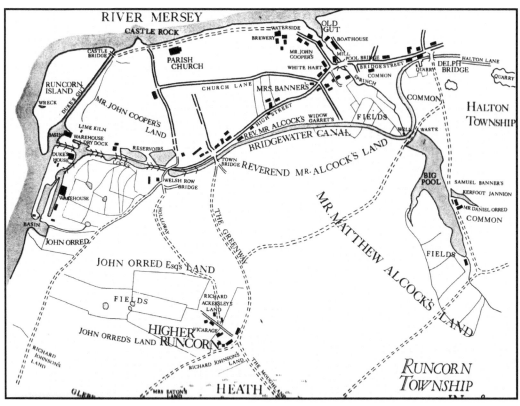

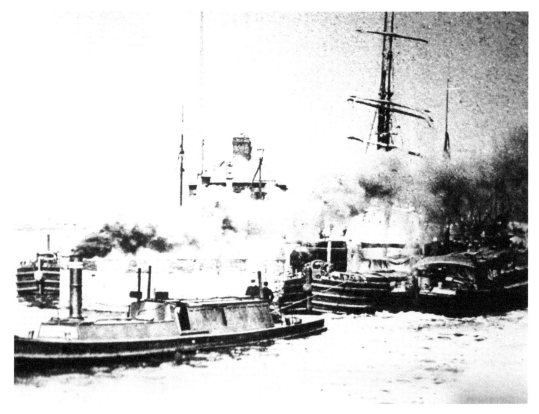

A tug assembling barges.

In 1804 another significant event increased Runcorn's trade: the opening for traffic of the Runcorn to Latchford Canal, known locally as the Old Quay Canal. Pigot's directory of 1822 states,

> The trade of the place has of late increased so much, that government have established a Customs house, and proclaimed it a free port. It has also lately become a place of resort for salt-water bathing; the fine air, the pleasantness of the neighbourhood (particularly' Halton Castle) and the exhilarating effects of the busy scene upon the river, constituting useful auxiliaries to the effects of the bath. In the quarries here, which lie contiguous to the canal, large quantities of free-stone are procured, of a very excellent quality.

It comes as a surprise that Runcorn hosted visitors from all over the area. The salt-water baths were opened in 1822, making Runcorn an early spa town. In 1831 the fine Belvedere terrace was built to provide accommodation and a promenade for the visitors.

The Weaver Navigation struggled due to low water levels and in 1796 a plan was drawn up to extend the canal to Weston Point, where the water was deeper. At Weston Point, a new lock connected the cut to a basin, and tide gates connect the basin to the Mersey. This cut was called the Weston Canal and was completed in 1810.

A lighthouse was requested at the outlet of the River Weaver into the River Mersey at Weston Point, as early as 1796. Records indicate that one was erected in 1810 but

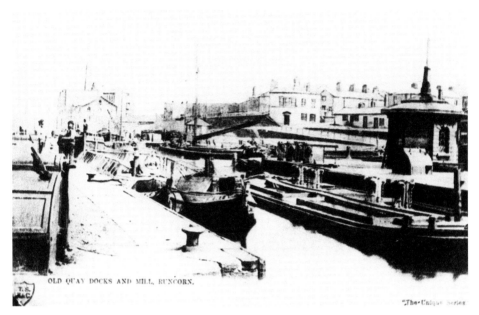

Old Quay.

Belvedere.

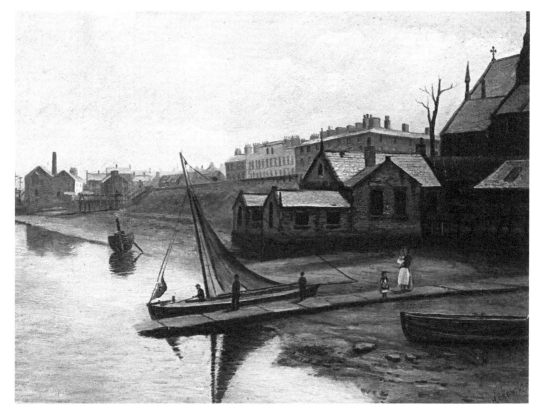

Ferry and Belvedere.

the red-sandstone lighthouse, built in 1843 for the Weaver Navigation Company, was decommissioned and demolished in 1960. It stood adjacent to the now derelict church on the confluence of the Weston Point docks on the River Weaver and the Manchester Ship Canal.

The salt trade on the canal was flourishing and Sunday working was considered essential, but pressure was mounting to end this practice. In 1841 the trustees of the Weaver Navigation built a fine Gothic church, Christ Church, at Weston Point for their employees and their families. They also built a vicarage and paid the vicar's stipend as well as covering costs for cleaners and choristers. The church was known as the Waterman's Church.

Edward Leader Williams had made great improvements to the Weaver including widening work, new cuts and locks and sluices and in 1865 he enlarged the Weaver docks to allow for seagoing vessels.

The coming of the Manchester Ship Canal brought great disruption. Slow decline followed and trade reduced from 200,000 tons in 1938 to 40,000 tons in 1954. The area is now surrounded by Eddie Stobart's docks. The church is boarded up and access is not allowed. This was a sad end for this historic church. In August 2007 the owners of the Port of Weston, the Westbury Property Fund, merged with the Eddie Stobart Group to form the Stobart Group Ltd. This group has developed the site into an inter-modal port facility to enable freight, currently carried by road, to be transported by rail and water. They have increased warehousing and built new container handling facilities.

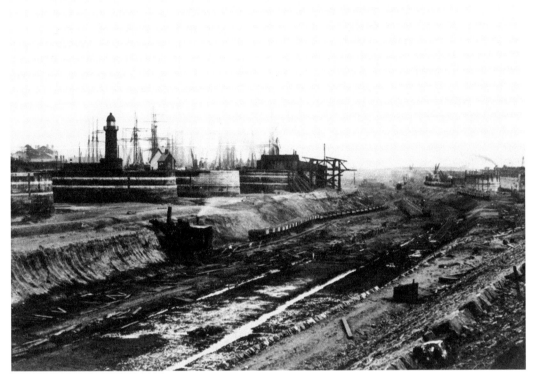

Above: Weston Lighthouse.

Below: Weston Point Saltport, 1892.

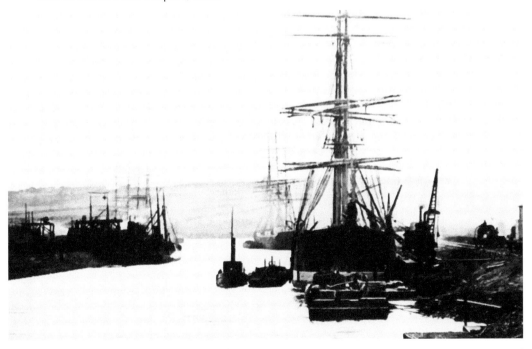

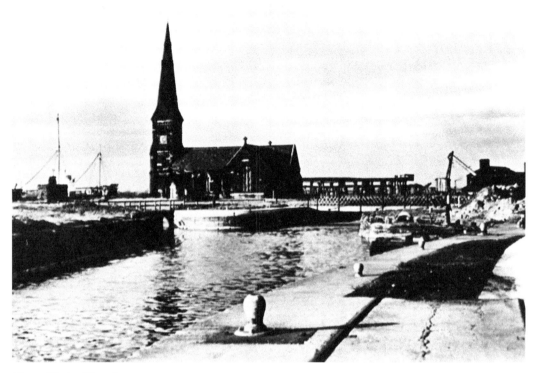

Above: Christ Church.

Below: Weston Point, 1911.

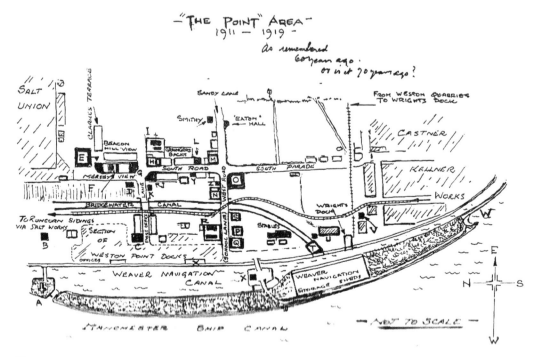

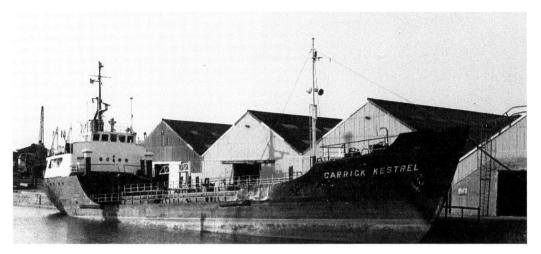

Weston Point Docks' chemical transporter *Carrick*.

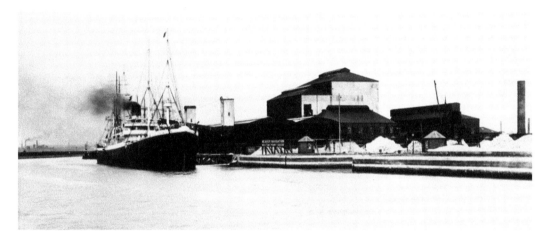

Weston Point Docks.

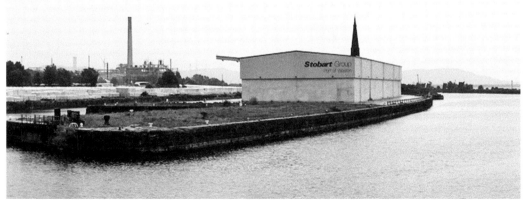

Stobart's Weston Dock. (Copyright David Dixon under Creative Commons 2.0)

SHIPBUILDING

By early 1800 small local builders were beginning to launch seagoing ships. The size of the ships was dictated by the fluctuating river levels. The early shipbuilders were William Wright and Charles Hickson. It was his son-in-law, Dennis Brundrit, who put Runcorn shipbuilding on the map when he inherited the yard in Mersey Street. He realised its importance to growing towns of welsh granite for road surfacing. He bought a quarry in Penmaenmawr and then started to build the boats capable of carrying large loads. The industry was quite primitive at this stage. The shipwrights used proven traditional methods. The oak frames were assembled on the slipways. The planks were heated and then hauled into place. Pitch and oakum were used to make the ships watertight. Gradually the process was modernised. The Old Quay docks were developed around 1829 and the river frontage was transformed, meaning sea-faring ships could now dock.

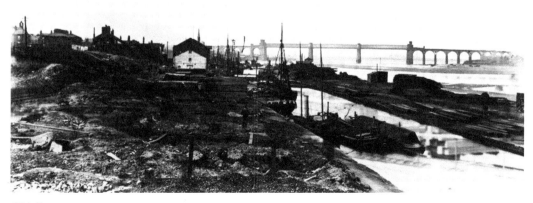

Old Quay.

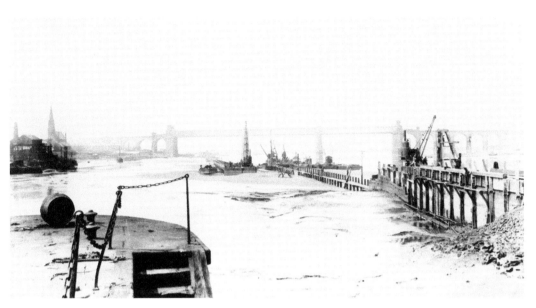

Old Quay Canal, 1890.

Originally the construction and repair yard of the Mersey and Irwell Navigation was in the Irwell at Manchester but by 1833 the work was transferred to Runcorn. In 1837 the workforce totalled 138. There were also now four boatyards in the area of Mersey Road: Brundrit & Hayes, Abels, Blundell & Mason, and Stubbs. Shipbuilding continued to flourish until the building of the railway bridge and the Manchester Ship Canal transformed the area.

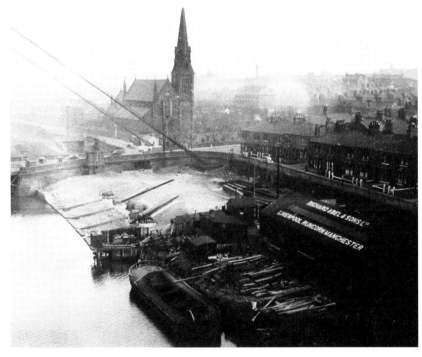

Abels
Boatyard.

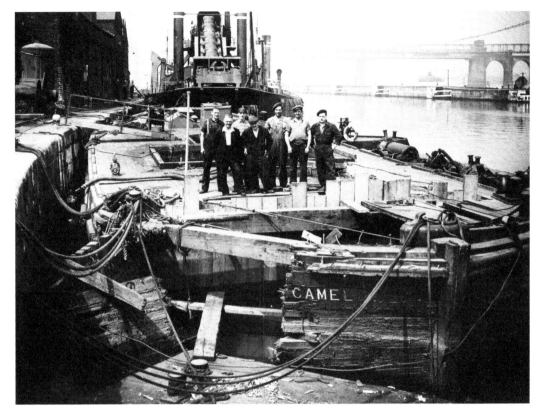

Old Quay *Camel* collision, 1953.

SOAP AND CHEMICAL INDUSTRY

Originally soap making was a cottage industry. Many people made soap-like substances in their own homes by boiling wood ashes with fat from the kitchen. To produce quality soap commercially a good supply of alkali was required. A method was needed to produce alkali from common salt. This was provided by Frenchman Nicholas Leblanc. It was his method that led to the modern chemical industry and its success in both Runcorn and Widnes. Once again strategic position allowed access to the raw materials and the means to export worldwide.

The first soap works was established by John Johnson on the south bank of the Bridgewater Canal around 1803. When he died the factory was leased until his two sons, Thomas and John, were able to take control. The enterprise was a great success and by 1841 they were

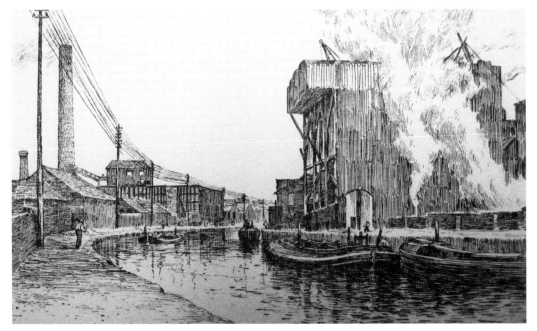

Soap works: Hazlehurst's on the left, Johnson's on the right.

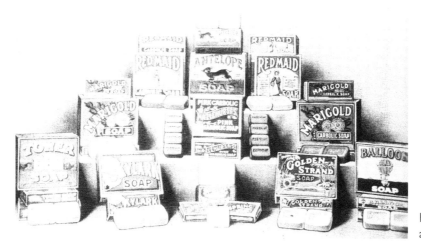

Hazlehurst's
attractive soap.

producing over 2,000 tons. They were even able to purchase a second factory on the Weaver Canal at Weston. However, there was competition. In 1816 Thomas Hazlehurst established a soap factory on the opposite bank of the Bridgewater Canal between the canal and High Street in Runcorn, called Camden Works. Both works were able to flourish through the century and provided much-needed employment.

Both companies built tall chimneys to disperse toxic fumes. The two chimneys became landmarks in Runcorn and dominated the view across the river from Widnes. The two enterprises both endowed the town with fine buildings. The Johnsons were Anglicans and gave generously for the building of Holy Trinity Church and a ragged school in 1853. The Hazlehursts became the most powerful family in the town and they left an immense legacy in Runcorn. They were Methodists and their enthusiasm resulted in Runcorn becoming a major centre for Methodism. Thomas had four sons: William, John, Thomas and Charles – who were all active members of the Methodist circuit. Thomas was known as 'Prince of the Wesleyans' and was responsible for building chapels in Runcorn including Halton Road and Trinity in Halton village. His outstanding legacy to Runcorn was to build St Paul's Chapel in High Street next to the Camden works.

Built in 1864 on their own land, St Paul's was said to be the finest building in the district. It had a handsome Italianate façade and glorious internal decoration; a church to be proud of, costing over £8,000. The church opened in November 1866. It is a tragedy that it was demolished in 1969. This prompted Pevsner to declare 'the town has lost its one distinctive building'.

There was also a legacy of fine houses built as a result of soap wealth. William lived in Camden House attached to the works, which can still be seen in High Street today. John lived in Roche House over the road and Thomas lived in Waterloo Road. Thomas later built a fine house on Weston Road called Prospect Villa and later Beaconsfield. The house had fine views across the Mersey. Sadly, it is no more and only the gateposts remain. We can, however, still see Thomas Johnson's fine villa built in the style of Queen Victoria's residence, Osborne House, on the Isle of Wight. The irony is that when the company was declared bankrupt it was his rival Thomas Hazlehurst who purchased it for £10,428 in 1874. It was later the home of Francis Boston of Puritan Tannery and is now the home of Runcorn Town Hall.

William retired from the business in 1849 and John retired in 1857, leaving Thomas junior and Charles to run it. The day-to-day business was conducted mainly by Charles,

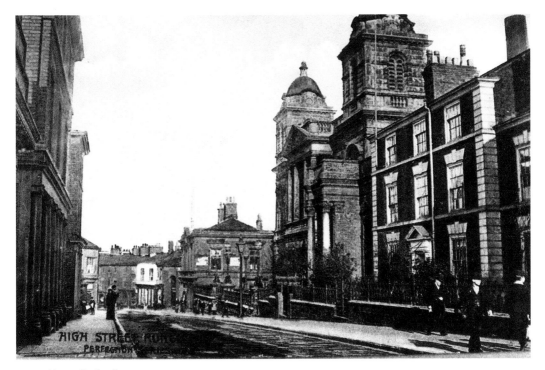

Above: St Paul's.

Below: Town Hall.

while Thomas junior concentrated on his religious interests. It continued to thrive and in 1866, their best year, each brother 'took home' a profit of £11,570. Following the deaths of Thomas junior and Charles the business was run by a board of directors. In 1890, in common with most of the other factories using the Leblanc process, the firm became part of the United Alkali Company. The firm's soaps continued to win awards at various international exhibitions until in 1911 the business was sold to Lever Brothers. Soap and alkali making then ceased and the factory was taken over and became Camden Tannery.

In 1865 Charles Wigg established a new chemical factory in Runcorn making soap and alkali. It was in the area of the Old Quay and was known as Old Quay Chemical Works. He worked at first in partnership with other famous chemical names, Neil Mathieson and Duncan McKechnie. In 1873 it was Mathieson who was named in an action by Sir Richard Brooke of Norton Priory for 'damage to his trees and pastures form noxious emissions'. His mansion at Norton was in direct line of prevailing wind from the factory, which no doubt encouraged Mathieson's decision to leave Runcorn and move across to Widnes. Wigg bought Grice's farm from the Johnsons and built Halton Lodge.

When MSC was built beside the works the area became known as Wigg Island. The works closed in 1930 but was reopened by the Ministry of Supply in 1940 to supply the war effort.

Halton Lodge.

THE QUARRIES

Runcorn Hill and Weston are blessed with fine-quality pink and red keuper sandstone. Quarrying was the first industry of the district. It is easily worked and is ideal for building purposes, being soft when quarried and then quickly hardening. An early project in 1734 provided stone for use in Grappenhall. The stone was transported by boat up to Wilderspool and from there horse-drawn carriages moved the stone to Grappenhall. In 1761 the Duke of Bridgewater used local sandstone for his locks. The first fully operating quarry was not on the hill but was William Grindrod's on Mill Brow. William Wright opened his business venture on Runcorn Hill in 1808, employing forty men known as 'stone getters'.

Sandstone.

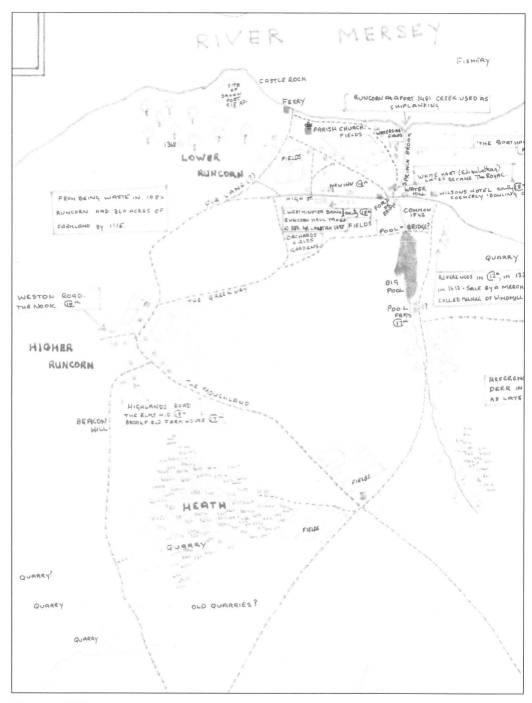

Quarries, 1770.

The quarry supplied stone for the vast dock construction in Liverpool. The quarry continued production for sixty years, and by 1840 there were many sites in the town. Denis Brundrit worked at Stenhills, William Bankes had a quarry at Weston and even

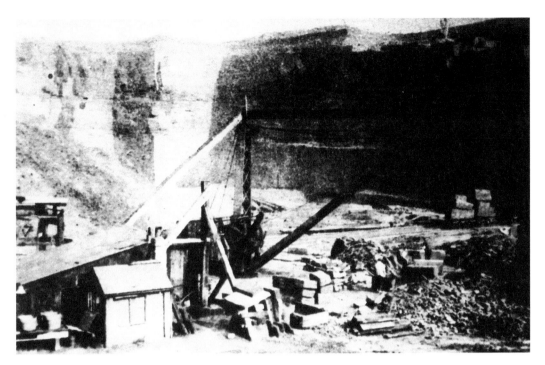

Above: Stone moving by tramway.

Below: John Tomkinson's quarry, 1900.

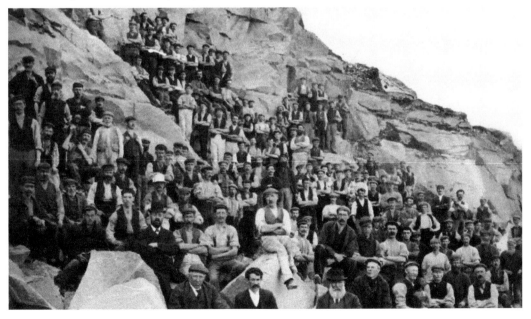

Sir Richard Brooke was working stone in Halton. Soon quarrymen from Wales and Cumbria were arriving in the town for employment. In 1850, 700 workmen were employed in John Tomkinson's in Weston.

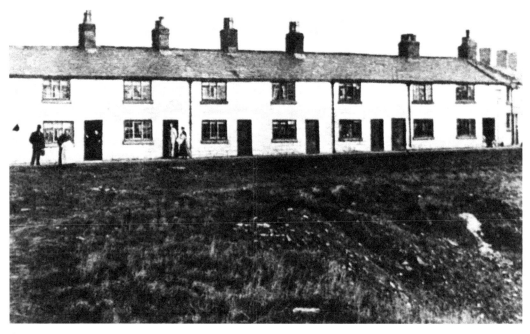

Quarry workers' cottages.

In the early days, horses were used to move the stone, but were later replaced by locomotives and steam. At Weston tramroads were used to convey the stone to the wharfs at Weston Point. Runcorn stone was renowned throughout the region and it can still be seen in many fine buildings locally, including Holy Trinity and All Saints in Runcorn and St Mary's in Halton, and further afield such as Tatton Hall in Knutsford. We can also see the stone in huge civic projects such as the railway viaduct in Stockport and at New Brighton. Runcorn stone even graced the docks of New York and San Francisco. The Wright family sold out to William Guest of Greenhill Road who also acquired the more profitable Weston quarry, which continued to supply stone until 1942.

THE TANNERIES

Tanning was an ancient industry practised in Cheshire for centuries. Cheshire is a dairy county, so most villages had small tanneries to process local hides and produce leather. The work was hard. It started with an arduous preparatory stage that could take several weeks. First, the animal skins were cleaned and softened with water. Once cleaned, the tanners still had to pound the hides to remove excess fat and flesh. Next, to loosen the hair follicles, they would either coat the hides with an alkaline lime mixture, leave the hides out to putrefy for months, or soak them in vats of urine before removal with a dull knife. This was a smelly business, so tanneries were always found on the outskirts of the village. Tanners used a chemical compound called tannin, derived from tree bark and certain plant leaves. Hides were stretched out on frames and immersed in vats containing concentrated amounts of tannin.

By 1865 tanning had become a major industry in Runcorn. Victorian armies had need of leather for boots and belts and business was booming. The Industrial Revolution was also

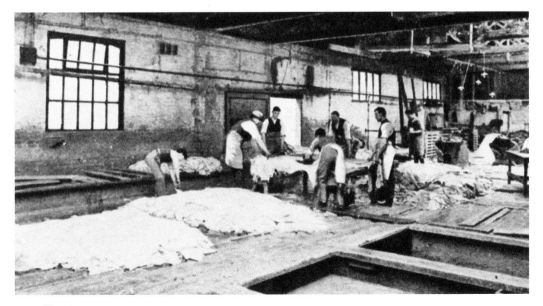

Tanning.

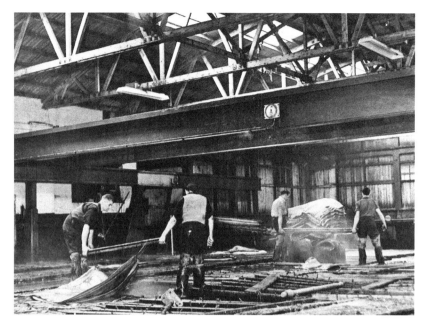

Left: Dipping, Highfield Tannery.

Below: Labs, Highfield Tannery.

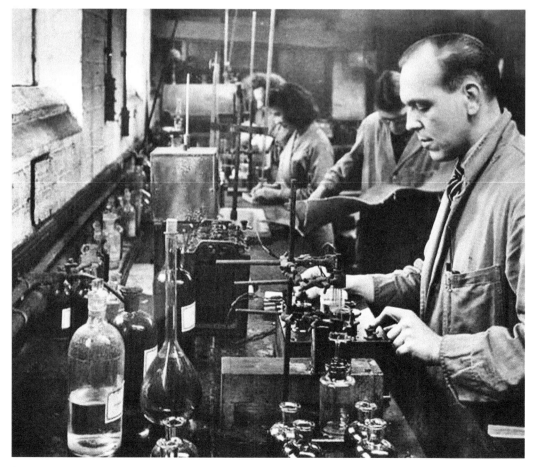

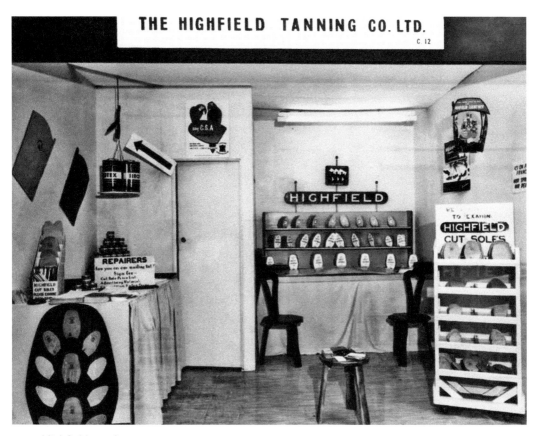

Highfield products.

bringing demand for good-quality leather belting for machines and engines. It was once again the canal that contributed to Runcorn becoming the largest centre for leather production in the country. The tanneries were all situated along the canal and coal, hides and other materials could be transported and access to docks allowed easy export. In 1890 there were four major businesses: Highfield, Camden, Astmoor and Puritan.

Highfield Tannery was situated along Halton Road near Hardwick Road in Astmoor and was the most successful. It had a wide-ranging product range, all classes of leather soles, thin leather for car seats and thick leather for suitcases and handbags.

In 1916 Robert Posner moved the Camden tannery to the old Hazlehurst Chemical Works on High Street. Astmoor Tannery opened in 1900, employed 170 men and processed 6,000 hides per week. It closed in 1945 and was later demolished for Astmoor Industrial Estate. The capacity of Highfield grew from fifty hides per week in 1888 to 5,000 in 1914. They would continue to flourish up until the Second World War.

MERSEY CROSSINGS

O ver the years there were many plans to bridge the Mersey at the Runcorn Gap. The first was when James Brindley, the talented engineer, planned the Bridgewater Canal. His bold plan was to build an aqueduct. It was never a serious option because of cost and opposition from Liverpool and Warrington. Ralph Dodd suggested a similar scheme in 1800 and again John Dumbell in 1813, but again these plans was not taken seriously.

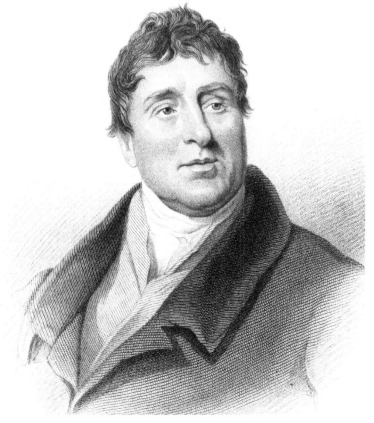

Thomas Telford.

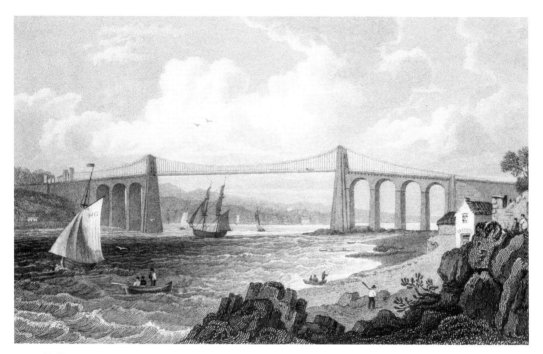

Telford's bridge at Menai.

In 1814 Liverpool Corporation commissioned Thomas Telford to investigate a suspension bridge of wrought iron. The design that Telford eventually came up with is very similar to his bridge at Menai. Telford's bridge at Runcorn was never built and there have been subsequent suggestions from civil engineers that wind pressure over such a large span would have made the bridge vulnerable. Although his bridge plan never materialised, his work can still be seen at Weston where he completed the Weston Canal and carried out work at the harbour at Weston Point.

THE RAILWAY BRIDGE

It was not until 1861 that another plan was proposed that would really bring the railway age to Runcorn. The London & North Western Railway obtained approval from Parliament to build a line from Aston to Ditton by way of a bridge across the Mersey. The plan was conceived not to bring advantage to Runcorn but shorten the journey from London to Liverpool. There is no doubt that placing the town on the main line was a great advantage. Runcorn did have a station in 1851 but it was actually at Sutton Weaver on the Warrington to Chester line. It was later renamed Runcorn Road and eventually Halton Station.

The first stone of the bridge was laid in 1864 by Philip Whiteway, a shipbuilder and quarry owner of Runcorn. By 1866 there was great rejoicing by the workers when the first main girders were settled into position. The construction work, however, caused problems for

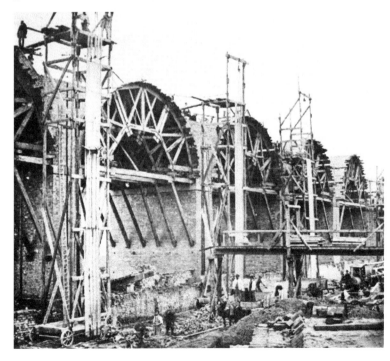

Railway bridge construction.

shipping trying to get to Old Quay Docks. The railway company was forced to provide small steamers to tow vessels safely through the obstructions.

The railway bridge brought much-needed construction work to the town, but it was not without tragedy. One such fatal accident was reported as follows:

Thomas Marsh a labourer on the bridge missed his footing and fell into the snig rocks The ferryman and his colleagues went to help him but he was bleeding profusely from his temple and was insensible. Samuel Lydiate the ferryman eventually managed to get him to the Mersey Hotel where the doctor declared that life was extinct. Thomas lived in Cross Street Runcorn and leaves a widow and three children to mourn his loss.

By 1868 the first locomotive, *Cheshire*, was able to cross the bridge. The twenty wagons contained 500 people. The bridge opened officially in 1869. Runcorn and Widnes were now connected and hundreds of workers could walk along the walkway to work in Runcorn or Widnes. This saw the demise of the ancient ferry. Just like today though the service was subject to complaints. The *Liverpool Echo* printed a letter in December 1869, stating that the service was advertised as four hours from London to Liverpool but this was far from the case: 'Is the four hour express a myth?'

MANCHESTER SHIP CANAL

Runcorn's fortunes were dominated by water and in 1894 yet another canal would be built, which was an engineering sensation. Manchester's dream of a passage to the sea would once again offer a lifeline to the town. Canal trade was declining with competition from the railways.

In the 1870s Manchester was experiencing a depression. The city needed lower transport costs and the Port of Liverpool was charging Manchester cotton men high rates to transport raw cotton. In April 181 members of the Manchester Chamber of Commerce passed a resolution in support of a deep wide waterway from Manchester via Runcorn to the sea. It was Daniel Adamson who was the driving force in the Manchester Ship Canal project. The canal took six years to build and employed 17,000 men. Although mechanical diggers were used, much of the work was still done with spades and wheelbarrows.

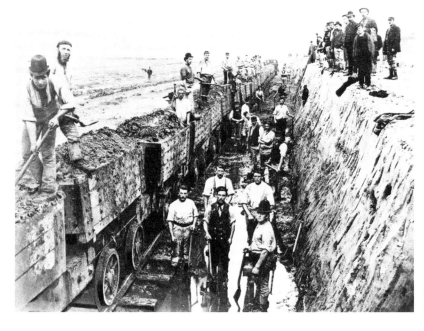

Manchester Ship Canal construction.

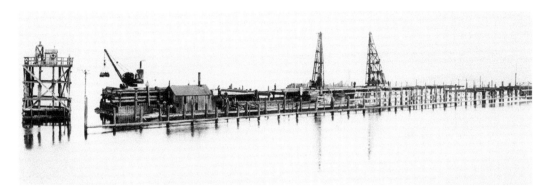

Above: Manchester Ship Canal pile driving.

Right: Excavating MSC at Old Quay, 1891.

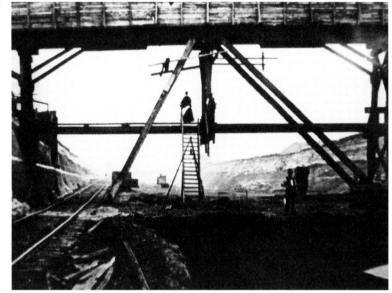

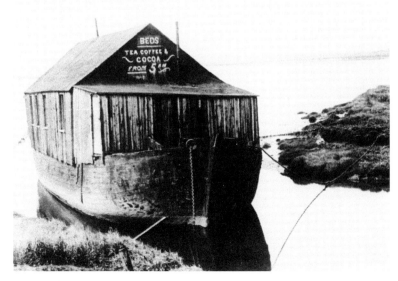

Noah's Ark.

Whole villages were built to house the navvies and even mission rooms were provided. The men earned 4½ pennies an hour and their weekly wage was just over £1 for a ten-hour day. The Bridgewater Canal remained but the Mersey and Irwell river navigation was damaged in the process of straightening and deepening the ship canal's route. Once again, the work was hard and dangerous and it was inevitable that there would be accidents. The major contractor was Thomas Andrew Walker. He must have been a compassionate employer as there was great mourning when he died in 1889. He had established a chain of first-aid stations and three base hospitals along the route of the canal. A surgeon, Robert Jones, was appointed in 1888. This was a very early attempt to provide health and safety support for the vulnerable workers. There were 3,000 major accidents as well as medical treatment for pneumonia and other common illnesses. He also cared for injured workers, offering them light duties. They became known as 'Walker's fragments'.

Other services were provided, including floating lodging houses, and food, tea and coffee were provided by travelling salesmen and women. This was a boom time for the town. Workers were flooding in and the shops, pubs and lodging houses were flourishing. The census of 1891 shows the population increased by 5,000. However, this resulted in a slump when many families left the town and it also decreased trade on the Bridgewater Canal. By November the Manchester Ship Canal was completed and ocean-going ships could sail right through Runcorn to Manchester. Runcorn's waterfront was changed forever.

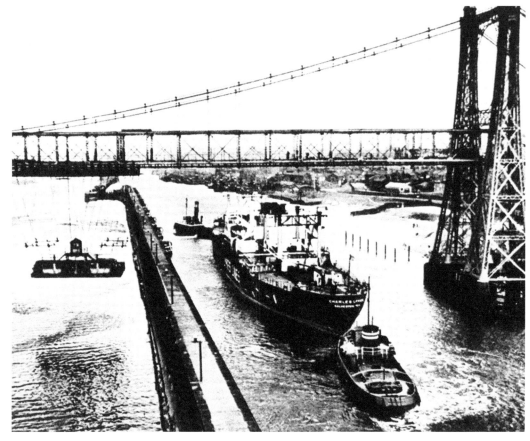

Manchester Ship Canal.

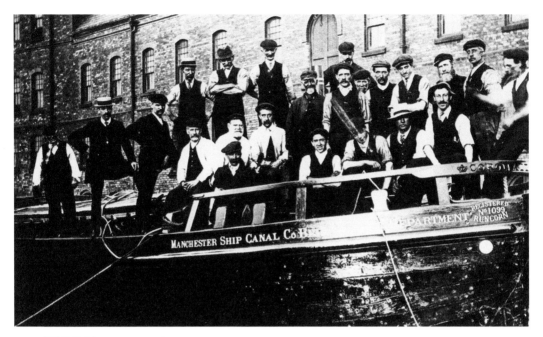

MSC Bridgewater workers.

The seawater baths and ferry slip disappeared, as did many of the Old Quay offices. Surprisingly the old ferry survived after pressure was placed on the railway company to honour its obligations and it was reopened in 1895. It was the Transporter that final saw the end of the ancient service.

Runcorn's shipbuilding industry was dying. The wooden vessels were not adequate. The schooner *Despatch* was the last ship to leave the slipway. MSC did however agree to site their tugboat repair yard at Old Quay and a new repair yard was established at The Sprinch.

Despatch.

The launch of the last Runcorn built schooner, *Despatch*, about to take to the water from Brundrit and Hayes' yard on the 4th May 1886.

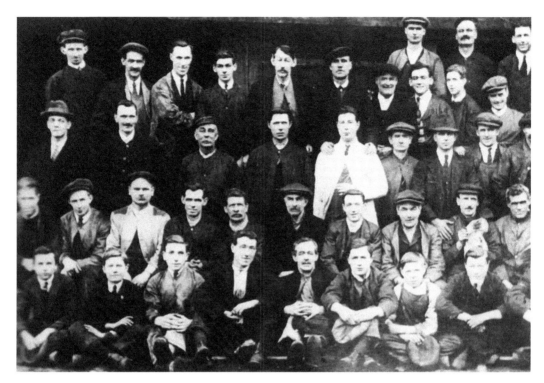

The Manchester Ship Canal's Sprinch boatbuilding and repair yard at the Big Pool on the Bridgewater Canal was claimed to be the finest of its type in Britain. The yard was responsible for the maintenance of over two hundred canal craft. The employees pose for a photograph c.1924. Top row: Frank Lovell, John Moores, Tom Mather. Row 4: Tom Mears, Edgar Wilkinson, Frank Burton, Norman Holt, Bob Boardman, Frank Hurst. Row 3: Frank Rushton, Arthur Lightfoot, George Jackson, Edward Ramsden, Bill Hoxworth, Jack Povey, Frank Faulkner, Wally Woodward, Joe Dale. Row 2: John Shallcross, Len Tomlinson, Bill Littler, Bob Sewel, ? Jones, Arthur Marsh, Henry Rone, Jack Rowlinson, Dick Pidcock (Snr.), Sam Royle. Front row: Herman Terreta, Bill Eastup, John Ashcroft, Jack Hampson, Tom Rodgerson, Dick Pidcock, Alf Ramsden, Ernie Green, Frank Urmson.

THE TRANSPORTER

Crossing the Runcorn Gap had always been an obstacle to trade between Cheshire and Lancashire and at this time the cost of a bridge was prohibitive. The decision was made to build a transporter bridge to allow vessels to cross the river. Surprisingly Widnes and Runcorn worked together, Widnes contributing £25,000 and Runcorn £10,000. Work began in 1901 and once again Runcorn welcomed new workers to the town. Sir John Brunner opened the bridge in May 1905.

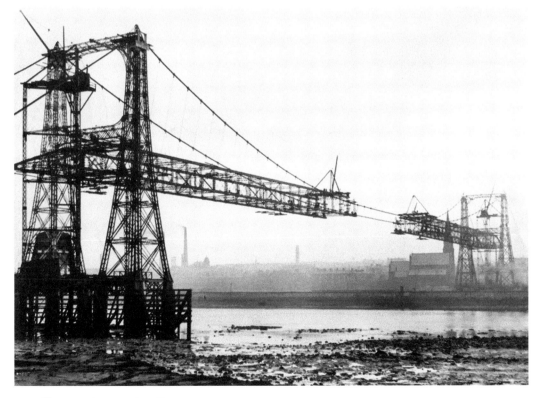

Transporter construction.

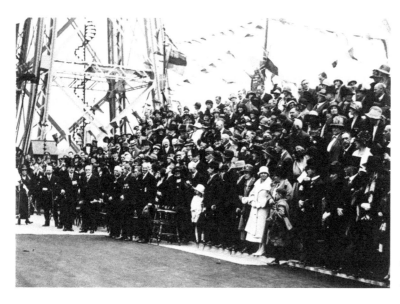

Transporter opening, 1905.

Both towns benefited from the bridge. For the first time materials could be transported across. Handcarts, cars and even omnibuses could be accommodated. Passengers were spared a long climb and walk across the railway bridge. The bridge now dominated the town. Waterloo Road was transformed from a quiet lane to a very busy street with passengers queuing to board. This encouraged shops to provide for the crowd. A favourite childhood pastime was to stand in the water below the Transporter car as it was leaving and ask the passengers to throw pennies down and watch the boys scramble in the water – this often proved very fruitful, especially when the car was busy.

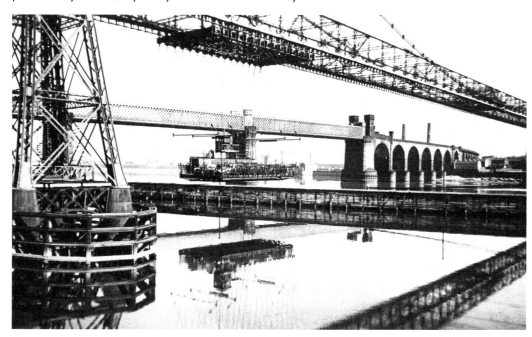

Above and opposite above: Transporter.

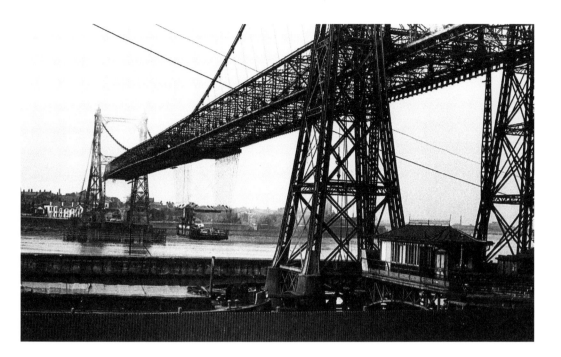

Despite the boost of the Transporter Bridge, Runcorn was in decline. Hazlehurst's were now producing soap for Lever Brothers and by 1910 the official address had become Bebington on the Wirral. Fortunately, Castner Kellner was expanding, although fluctuation in demand was always a problem in the chemical industry. Castner's fortunes benefited from the arrival of Dr Harry Baker as chief chemist in 1897. He had been a student of two internationally famous chemists: Professor Sir Henry Roscoe FRS in Manchester and Professor Robert Bunsen in Heidelberg. He worked on the development of chlorine production by the electrolysis of brine pumped from central Cheshire to the newly opened factory at the site at Weston Point, using the famous mercury rocking cells. A power station was built and a few years later, in 1912, they were supplying electricity to Runcorn and Widnes.

The company was aided by market developments in the 1920s, which led to greater use of chlorine in the form of chloro-ethylene solvents. In 1916 the company became associated with Brunner Mond & Co., both of which became part of Imperial Chemical Industries in 1926.

Another new industry was attracted to Runcorn in 1911. Evans, Lescher & Webb established a medical research laboratory at Crofton Lodge in Westfield Road. Working in conjunction with Liverpool University, the company began to make biological medicines for humans and animals; these included sera and antitoxins for diphtheria, tetanus and meningitis. In 1916 the firm established their Ellesmere works in Gas Street for the manufacture of synthetic pharmaceutical drugs. Their pioneering work saved millions of lives worldwide.

In 1903 the Victoria Memorial Hospital was opened on The Holloway (known as the Cottage Hospital). It was a welcome facility for the town, providing beds for thirty-two people and a large outpatients department. Mr Simpson would come from Liverpool to perform surgery. Visiting was twice a week! There was no National Health Service as we know it today. The hospital was financed by generous support from the people of Runcorn. An isolation hospital was also built on Weston Road.

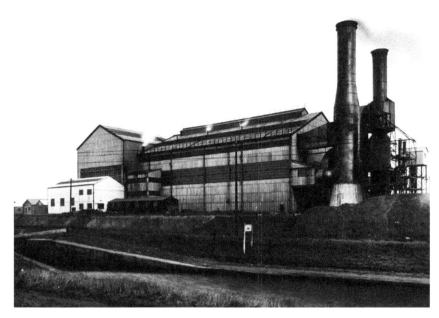

Weston
Point
Power
Station.

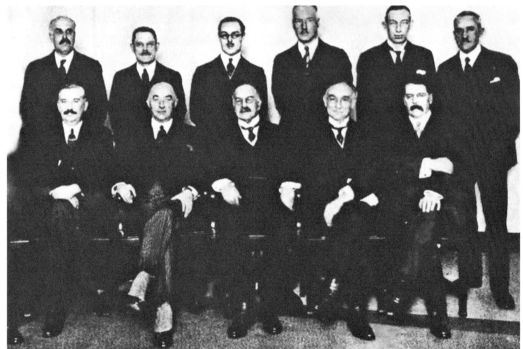

TWO RARE PICTURES OF 1926. (ABOVE) *The first meeting of the Board of Directors of I.C.I., all present with the exception of Lord Ashfield. Seated (left to right) Sir John Brunner, Mr. H. J. Mitchell, Sir Harry McGowan, Sir Alfred Mond, Lord Reading, Sir Max Muspratt. Standing (left to right) Sir Josiah Stamp, Mr. B. E. Todhunter, Mr. Henry Mond, Colonel Pollitt, Mr. J. G. Nicholson, Mr. G. C. Clayton.*

ICI founders, 1926.

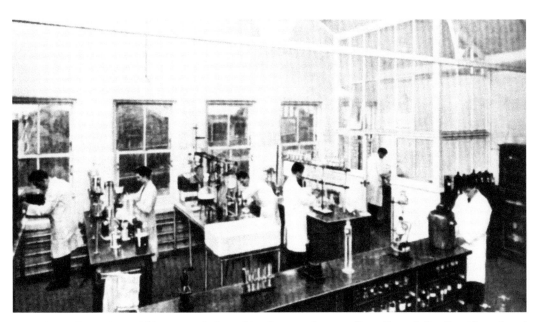

Above: Evans Lab, 1937: Jimmy Collins, Olga Sinclair, George Shaw, Ernie Jolley, Fred Rymill and Jack Whitney.

Below: Nurses, Victoria Memorial Hospital.

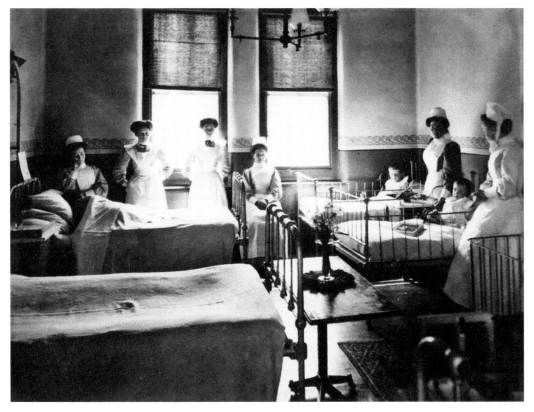

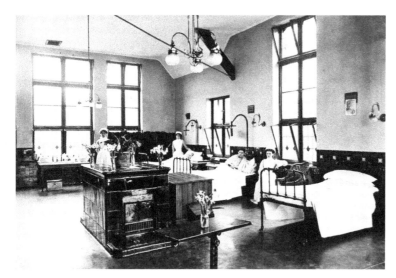

Nurses, Victoria
Memorial Hospital.

Isolation hospital,
Weston Road.

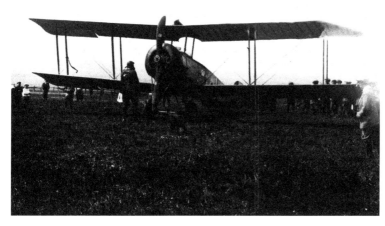

Plane landing
at Grice's farm
c. 1914.

FIRST WORLD WAR

Joe Broady was born to Joseph and Ada in 1908 in Cartwright Street, Runcorn. Here are his memories:

The outbreak of the First World War had an immense impact on our family in Runcorn. My father and eldest brother answered the call. My father joined the Army and my brother the Navy. My other two brothers, both in their teens, were put to work on the canal barges. Most families were depleted by joining the Forces or to make up the loss of manpower in industry. Most foods were in short supply and joining a queue for food on ration was a daily occurrence, to try to obtain the bare necessities. There was no time for recreation; even the young had to make sacrifices towards the war effort.

By 1917 the war in France had taken a serious turn. Casualties were enormous, both on land and sea, German submarines sending many ships to the bottom. We had one piece of good news – the Americans were sending us huge supplies and were mobilising an expeditionary force to come to our aid. It was during the summer of 1917 that both my father and brother came home on leave unexpectedly – what a celebration we had. Princess Street had been decorated to welcome home our hero Private Todger Jones, who had won the Victoria Cross. Tables were brought out into the street, food seemed to appear from all quarters. The party went on well into the night; even the children were allowed to stay up.

It was while my father and brother were home on leave that we heard of the Holocaust that was happening on the battlefields and at sea. My brother had been at the Battle of Jutland in the battleship *Lion* with Admiral Beatty in command, and my father on the Somme. It was with feelings of gloom when they had to return to active service; we went to the station to see them off. Father was going to Palestine with the 5th Cheshire Regiment and my brother to Scapa Flow. It was weeks before we settled down to normality after all the excitement of the last few weeks, but our daily routine had to carry on despite our worries.

With the signing of the Armistice in November all families were waiting with expectation at the return of their loved ones. Some had long waits, other were more fortunate, whilst many knew that their loved ones had paid the supreme sacrifice and would never return.

My family were one of the lucky ones. My father and brother were demobbed early in 1918 and our home returned to normality again, except that work was hard to come by,

with industry slow in recovering to the change from war effort to peace. My father returned to his job at Wigg Works, but it was only for three days a week due to the non-arrival of raw materials required from overseas, and only the home market could be supplied.

Joe Broady always yearned for adventure and after the war

I ran away to sea at the age of fourteen and signed onto the two-masted schooner *Weston Lass* as cook/cabin boy. We took on a cargo of coal for Mevagissey in Cornwall. We left Runcorn Docks and were towed to anchorage in the Sloyne (Mersey). After two days waiting for a fair wind we sailed out of the river and headed out to sea. The first few days at sea soon took toll of my adventurous spirit, for I was terribly seasick and wishing I was back on dry land again. This being my first sea trip the crew were very understanding and did all they could for me, forcing me to eat each time I vomited.

We had to put into Milford Haven due to the bad weather, and lay there at anchor for four days. This respite helped me to recover and I soon became acclimatised to life on board, carrying out my duties, cooking for the crew and keeping the cabins clean and tidy. The cooking was all done in the galley situated before or aft of the main mast. The food had to be carried from the galley to the saloon in the after part of the ship, where all the crew dined. The saloon was also the chartroom and the captain and mate's quarters. It was quite an ordeal carrying the food from the galley to the saloon, and many a meal was lost overboard in rough weather.

The weather became fine and we again set sail, and with a fair wind we arrived in Mevagissey. The cargo had to be winched out of the hold by hand winch and tipped into horse and carts drawn up on the quayside. For the next four years I sailed in these ships, namely the *Mary Sinclair, The Duchess, Alert, Snowflake* and *Emily Warbreck*, graduating from cabin boy to ordinary seaman to able seaman, making various voyages around the coast and the continent.

My most memorable voyage was in the *Snowflake*. We loaded a cargo of salt at Weston Point for St John's, Newfoundland. After only twelve hours at anchor we headed out of

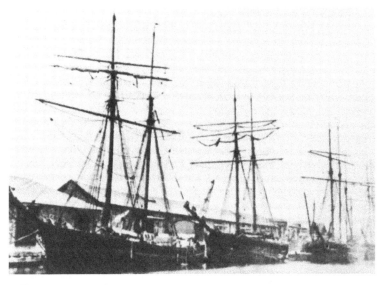

The schooners *Snowflake, M.E. Johnson, Englishman* and *Dunvegan* at Runcorn in the 1920s.

Snowflake.

the river, on reaching the Bar we turned south. We reached South Stack lighthouse when the weather changed and began to blow hard. For the next seven days we got little watch below, as it was all hands on deck reefing and turning sails and making slow headway against the strong wind. We eventually put into Cork harbour and lay at anchor for five days repairing sails, ropes and other minor damage. We took on fresh food and water and sailed out of the harbour and headed out into the Atlantic. The weather was moderate and we were making steady five and six knots. With fine weather the crew had time to carry out various tasks as washing down the decks, cleaning paintworks, and washing personal clothing. There was only two men on watch at a time; one at the helm and the other on look out. We were passed by several large ships including the *Andania* and *Cedric*; it was a pleasant sight to see the passengers lining the rails and waving to us. Most of the large ships would close in and hail us asking if we required anything and wishing us 'God speed'. The crossing took twenty-one days and it was a pleasant sight to see the fishing fleet off the Newfoundland banks and know we would soon be in port again.

We spent six days in port discharging our cargo of salt and loading a cargo of salted herrings in barrels for La Coruna in northern Spain. During our stay in port it was a change to sample fresh food again after a diet of salt beef, pork and hard sea biscuits. We left St John's fully refreshed after our stay in port and ready to face the voyage back across the Atlantic. The voyage across to Spain took nineteen days with a fair wind and the Gulf Stream to assist us. This was a reasonable time for this type of vessel.

After discharging our cargo of fish in La Coruna we sailed around the coast of Spain to Bilbao, where we loaded a cargo of copper ore for a home port. The passage home was uneventful and it was pleasing to see my family and friends again. The experience I gained serving in these vessels served me well in my later years and I would not have missed the experience for anything.

The conditions the crews endured would not be tolerated in this present age. Wages for a cook/cabin boy was one pound per month, and able seaman six pounds, sailmaker or bosun eight pounds, and mate ten pounds. These rates included accommodation. The crew, with the exception of the captain and the mate, were accommodated in the forecastle in the forepart of the ship, sleeping in hammocks, but some vessels were fitted with bunks. The food when in port was fairly good, but at sea on a long voyage consisted of salt beef, salt pork and bacon, potatoes, dry beans, dry peas, molasses and sea biscuits.

The watches at sea were four hours on watch and four hours below with two watches of two hours each, between 4 p.m. and 8 p.m. – these were called 'dog watches', which alternated the middle watch from midnight to 4 a.m. Some of forecastles were alive with vermin, bugs, lice, fleas, etc. and it was a common sight when in port to see the Port Health Authorities aboard the vessels fumigating the crew's living quarters.

In those days the docks at Runcorn and Weston Point were full of ships both sail and steam coasters and it was possible to cross from one side of the dock to the other on the decks of the sailing vessels. Life was hard and dangerous and many local seamen lost their lives serving in these ships.

It was an experience I shall always remember and grateful that I had the opportunity to take part in this wonderful age of sail. We must all accept progress, but at the same time remember that this was an age when the ships were made of wood, but the crews who sailed in them were men of steel.

Immediately after the war Castner's rapidly developed at Weston Point. Company houses were built for the workers. Roscoe Crescent, Mather Ave and Sandy Lane were completed.

Castner's and United Alkali merged with Brunner Mond to form ICI in 1926.

Despite these developments the town was still suffering. Unemployment was increasing; 290 in 1928, 732 in 1929 and by 1930 it had increased to 1,044 men and boys. Those who had jobs were struggling with part-time working. It was a common sight to see men waiting at the factory gate hoping for a day's casual labour. In 1931 the unemployment benefit for a man, wife and two children was 27/3d. This benefit was only paid for twenty-six weeks and payments were now regulated by the much-hated means test.

There was still plenty of work to be found in the tanneries, especially in Puritan Tannery, which was the most modern tannery in Runcorn. It was the Puritan Tannery that became internationally known and even came to the attention of Hitler!

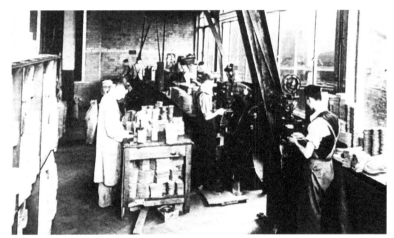

Left: Workers at Puritan Tannery.

Below left: Puritan. This advert was displayed at many railway stations.

Below right: Puritan advert.

For longer wear and greater comfort...

PURITAN
Leather Soles

PURITAN TANNERIES LTD · RUNCORN · CHESHIRE

28

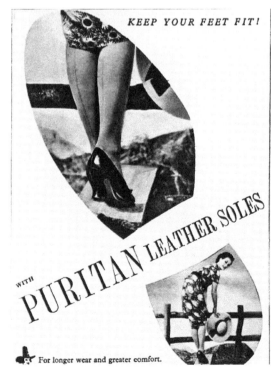

KEEP YOUR FEET FIT!

WITH PURITAN LEATHER SOLES

For longer wear and greater comfort.

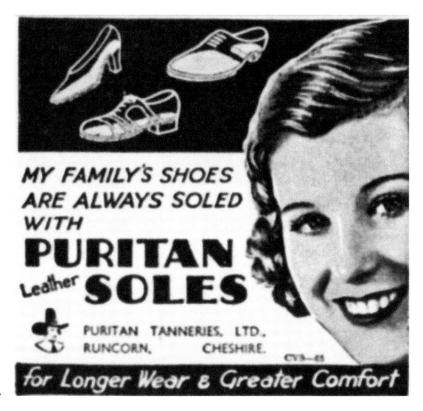

Puritan advert.

Geoff Dutton explains,

My Uncle George was a regular in The Cheshires in the First World War. He was stationed at The Curragh in Ireland before he left for France. He was part of the rearguard when unfortunately the unit ran out of ammunition. The Germans gave them two options: either surrender or be shot. Luckily, they took the wise decision. He was in a prisoner of war camp in Munster and here he became fluent in German. This was to come in very useful, as after the war he got a job in the Puritan Tannery as PA to Henry Boston who owned the tannery. He lived at Halton Grange until 1932 – hence Boston Avenue. The company flourished and was so famous that it had a wall-sized poster at Euston station – '187 miles to Runcorn home of Puritan tannery'.

This was seen by the German Ambassador in London, Von Ribbentrop, and he alerted Hitler, who was very fond of good English leather. In June 1938 Uncle George and Boston were invited to meet Hitler in Germany. They first met him in Munich and then were invited to Berchtesgaden in the Bavarian Alps. The meetings went well and they expected to secure the contract to supply the Wehrmacht with leather for jackboots, belts, etc. Sadly, the war put an end to this lucrative contract.

SECOND WORLD WAR

By 1938 war was threatening and the chemical industry in Runcorn and Widnes was to prove vital to the war effort. Chemical work became a reserved occupation. Rocksavage was built on the old Johnson's factory to produce chlorine and caustic soda. It was operated by ICI. Wigg Island became a centre for chemicals for the war effort. Randle Works on Wigg Island was producing deadly mustard gas as well as acids and ammonia. The town gave the works the nickname 'Hush Hush', but everyone knew the deadly work that was a carried out there.

Irene Haslam remembers her days at Randle's:

I made and filled shells with mustard gas and tear gas. I did not worry about the danger; I was more concerned with getting the right bus as there were hundreds of buses taking

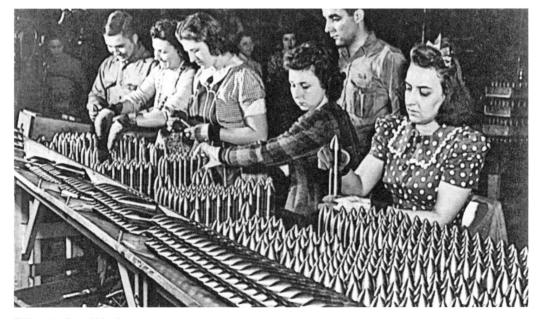

Filling shells at Wigg's.

hundreds of workers. They would come as far as Liverpool. I was very conscious that I was helping the boys away in the war.

George VI and Queen Mary visited the factory during the war. The workers were strictly monitored and had to take a bath after their shift. The shifts were long, as the war required a continuous process. They often ate on-site and slept in the work's air-raid shelters. It is thankful that these gases were never actually used. After the war the army was brought in to clear the nasty chemicals. The tanneries were busy producing leather for the war effort. Air-raid shelters were built but in fact, despite the worries, Runcorn was not subject to the blitz that Liverpool and Manchester suffered. Bridgewater House was taken over by the RAF at the outbreak of the war and the site housed barrage balloons to protect the docks from enemy bombers. In 1939 over 20,000 gas masks were delivered to Runcorn and air-raid sirens were tested.

Gas mask.

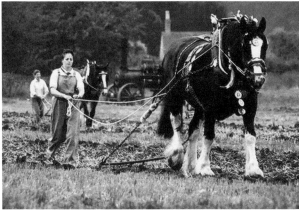

The land girls. (Under Creative Commons 2.0)

Scroll of Honour
1939 – 1945

Presented by his Companions at
Puritan Tanneries
in Honoured Memory of
Stanley Norman Yates
Ordinary Seaman, Royal Navy
who endured hardness, faced danger
and finally passed out of the sight of
men by the path of duty.

Stanley Norman Yates.

The local paper announced that black-out would be compulsory and violations prosecuted. Harold Hamlett of Regent Street, Alexander Levy of Church Street and John Nyland publican of Egerton Street were each fined 40 shillings for failing to observe these lighting restrictions. War work at Castner's was also dangerous. In June 1941 Harry Orme, aged forty-eight, of Shaw Street, Runcorn, met a tragic death down No. 2 chute whilst working as a boilerman. It was ironic that he met his death after warning another worker to use the lifelines provided or risk death moving the coal.

On 29 January 1941 all schoolchildren had to assemble to receive instructions for evacuation. In September 1941 fifteen-year-old Ernest Hough of Gilbert Street was recorded lost at sea – his ship was torpedoed. He was Runcorn's youngest war casualty.

There was much rejoicing on 8 May 1945 when Runcorn celebrated VE Day. Dorothy (Bunty) Ryder's memories of life in the Land Army and The Red Lion Preston Brook are as follows:

I was born in Frodsham. My dad was in the military and we soon had to move with the regiment to Aldershot and then we moved about quite a lot. I had two sisters, Mary and Marjorie. Dad was invalided out of the army and the family moved to Port Sunlight on the Wirral. Difficult times, but he managed to get a job with Lever Bros but sadly he was taken ill again and died in his thirties.

Mum had to cope on a widow's pension and she took a job cleaning at Lever Bros to make out. In 1942 mum died. I was only fifteen and the war was on. I had to move to relatives in Bebington. I missed my mum and dad and had itchy feet so I decided to join women's lands army. They rather reluctantly took me on. I took a bus from Bebington to Chester and then to Daresbury. When the bus stopped at Frodsham I realised this was where I was born at Drill Hall house, which is now a Chinese restaurant. I went many years later with my sister. We had a Chinese meal. She was rather upset to find they had turned her bedroom into the gent's toilets.

I worked for a very nice farmer, Tom Warburton, in Daresbury. We were very well fed and looked after. We did general farm work, milking and field work. We had to be back at the hostel for 10 p.m. I was only seventeen, so I did not mind but some of the other girls were much older and they rather resisted this. The hostel was the Old Vicarage. The farm was very well run and I spent six happy years on the farm with cows, ducks and horses.

I met Frank on the farm. He was an apprentice brick layer. He was pointing brickwork on the farm. We married in 1950. I wanted a quiet wedding. I told my mother-in-law I was to wear a grey suit and pink hat. She said 'you cannot marry in grey you rue the day'.

So I had a pretty dress. It was low-key as I wanted to be independent and pay for it myself. We went to London for honeymoon. We travelled on two land army travel vouchers. We had a wonderful week.

Frank's brother died and Frank had to return to Preston Brook to run the family milk haulage business. We collected milk from the farms and delivered to Co-ops all around.

It was hard for Frank as the men had seen him grow up. We opened a petrol station next to the pub in Preston Brook. I helped to serve the petrol.

When the pub next door came available we applied for a licence and got it. We were now running two businesses. It was a quiet village pub but when Murdishaw was built it became much busier. I got to know the newcomers. They were very nice people. I asked a couple 'do you like Murdishaw?' They said 'Its lovely and we have a garden.' I employed girls from Murdishaw who worked very hard for me. When Frank died, suddenly in 1977, I had to prove to Greenalls that I could do the job. They call it the 'widow's year'. I ran the pub alone for seven years. Suddenly I decided that I had had enough. I was fifty-seven and too late really. I thought 'what am I going to do'. I contacted *The Lady*. I applied for a job as housekeeper for a man in Kensington but London life was not for me.

After the war the Transporter was still the only way to cross the river but it was forty years old and totally inadequate for the volume of traffic. The trade on the canal was still thriving. Evelyn Hayes remembers her first visit to Runcorn:

I first came to Runcorn in 1944. My fiancé, a young soldier from Runcorn, took me across on the Transporter. I could cope with London bombs but that trip scared the living daylights out of me. I could not sit down. It was in January and ice covered the rails. The carriage cracked and banged, stopped and started, and was swinging alarmingly. When we came back I insisted we walked back over the railway bridge.

I never planned to stay but we married and in 1948 we moved to Runcorn, and here I am sixty years later. I grew to love the town and the canal fascinated me. Whenever I crossed Savage's bridge I would stop and walk to top locks to watch the busy scene. There would be youngsters with buckets collecting coal and many canal characters. One, I remember, was an old lady dressed in black and always smoking a pipe. I marvelled at how the women managed to bring up a family, to cook and keep everything so clean

in such a tiny tiny space. One lady nearly drowned as strangely very few of the canal folk could actually swim. Babies were born, mothers having to give birth in appalling cramped conditions. Life was hard, working long hours and regulations were strict, so everyone was always looking out for the inspectors. Finances were insecure as the family was only paid by the load. Despite all this they were one large canal family and marriages and christenings were celebrated with large parties and the boats were decorated for the occasion.

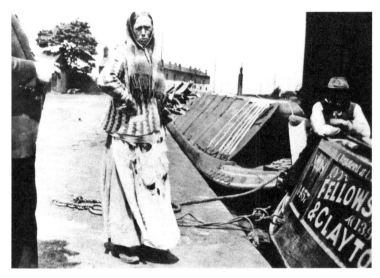

Left: Boat lady.

Below: Canal families.

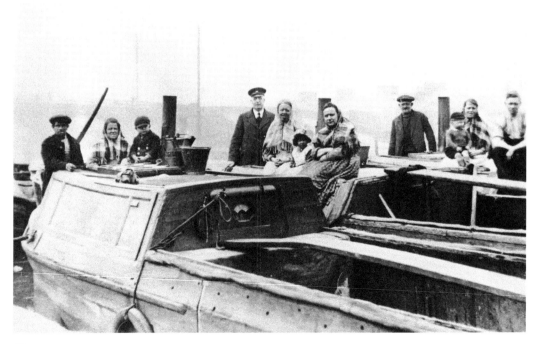

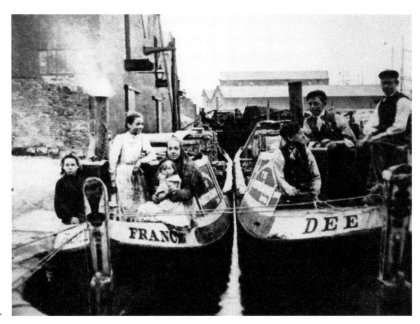

Canal families.

Hilda was actually born into canal life and there are few people still alive who can tell the bargee's story. Here are her memories:

I was born on the narrowboat *Speedy*, a potter's boat at Weston Point, in 1932. It was five more years on the boat before we moved into Runcorn. Life could be rather lonely and it was always a pleasure when the other boats arrived at Runcorn.

My family were many generations of boat people. I have great happy memories of the great family links and on Saturday night all the fellows would go off to the pub and bring back beer for the women. Then out would come the accordions and we would all enjoy singing and dancing. At the time the popular song was 'It's a sin to tell a lie' and it was my party piece. We always had a dog, as we were vulnerable on the canal side to be robbed of our load of pots, coal or sugar. We always tied up together.

The boat people were regarded with suspicion and sometimes called dirty but they were meticulous. Despite having no running water and no toilets on the boats the women kept the boats spotless. Everything was scrubbed on a Saturday night when the boats were empty.

On overnight stays there would be trips to the cinema and theatre in Runcorn. When I was five it was decided to leave the boats so that I could attend school in Granville Street. Dad got a job at Rocksavage. He could not read or write but they were looking for riggers and his skill with ropes got him the job. My father missed the boat life but mother had no intention of going back. The boats were horse drawn and were very important to the family both emotionally and economically and a sad loss when they died. 'Dolly' had to be sold and was greatly missed. Another horse had to be put down after a fall and this was a disaster as we had to buy the horse on the never-never and we had to pay rent for the boats. We ate well. A pot was always bubbling on the boat and the range was always lit. My father had a gun but perhaps not a licence and often curlew or rabbit were on the menu.

RUNCORN WIDNES ROAD BRIDGE

t was recognised as early as 1947 that a high-level road bridge was needed to cross the Mersey. The Transporter was now becoming unreliable and had to be closed at times for essential maintenance. The government restriction on capital expenditure meant that work on a much-needed bridge was deferred. In 1951 the Lancashire and Cheshire County Councils stressed the need for immediate action. Surprisingly the Ministry of Transport wanted to rebuild the Transporter! The first proposal was for only a single two-lane carriageway with one footpath. It was 1956 when at last the design of the bridge was finally agreed. Although this was a major development for Runcorn, it also meant that many people lost their home.

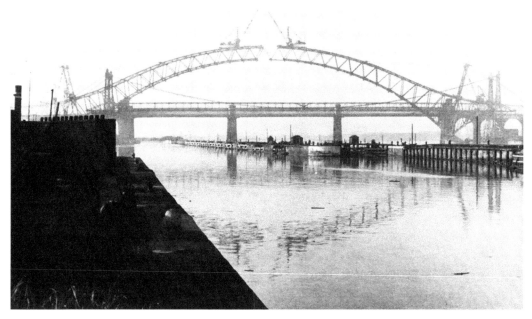

The road bridge construction.

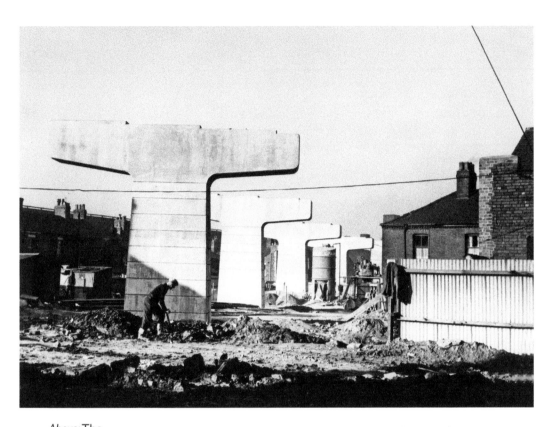

Above: The road bridge construction.

Right: The road bridge construction.

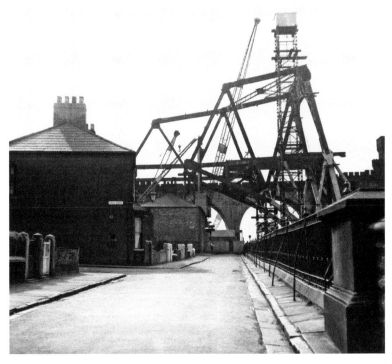

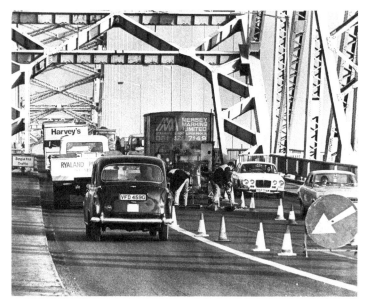

Road bridge traffic.

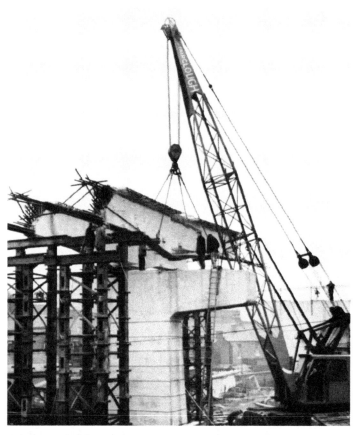

The giant Lorain Motocrane was used to position the deck beams over the piers.

Lorain motocrane.

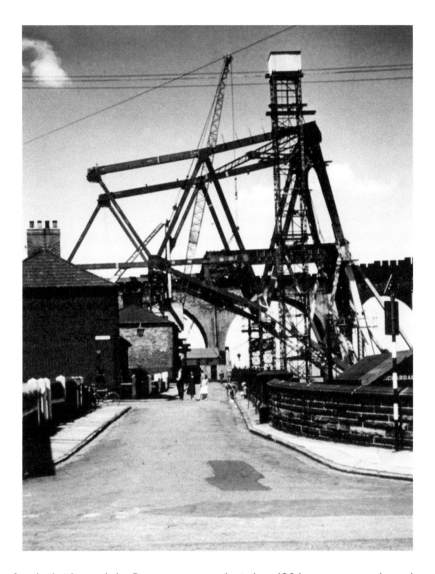

Road bridge
construction.

To make way for the bridge and the Runcorn approach viaduct 120 houses, two pubs and two garages were demolished by Cheshire County Council. Runcorn Urban District built houses at Windsor Grove and Penn Lane to rehouse these families. Once again the workers flooded into the town to work on the bridge. And again it was difficult and dangerous work. In 1961, when the bridge was being painted, Jack Thomas accomplished a task of great bravery 400 feet above the river. He had to crawl over wet paint in the pitch dark to put out a fire. When he was safely down he was daubed in yellow paint and said, 'I have never done any climbing before. It was bad enough going up but it was murder coming down.'

By 1975 the bridge was so busy that there was a need to increase the bridge to four lanes.

In 1977 the bridge was renamed the Silver Jubilee Bridge to commemorate the Queen's Silver Jubilee.

Runcorn was now on a major route between north Cheshire and south Lancashire. The bridge brought prosperity back to Runcorn Docks and Weston Point Docks. Trade at both ports was greatly improved.

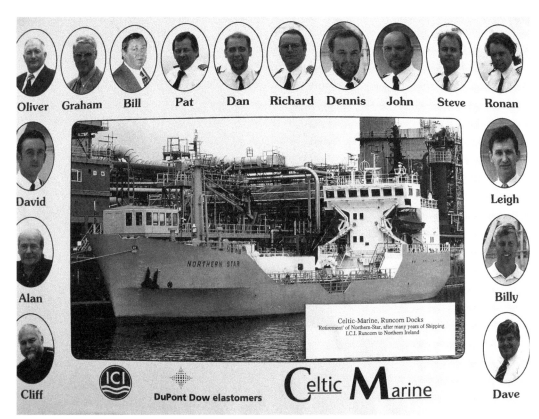

Oliver Graham Bill Pat Dan Richard Dennis John Steve Ronan

David

Alan

Cliff

Leigh

Billy

Dave

NORTHERN STAR

Celtic-Marine, Runcorn Docks
'Retirement' of Northern-Star, after many years of Shipping
I.C.I. Runcorn to Northern Ireland

ICI DuPont Dow elastomers Celtic Marine

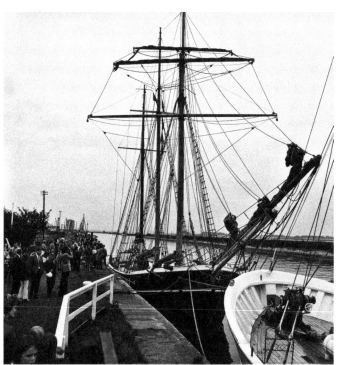

Above: Runcorn Docks.
(© aaronphotoarchive.org)

Left: Onedin Line's
Charlotte Rhodes in
Runcorn Docks, 1973.
(© aaronphotoarchive.org)

POST-WAR TRADE AND INDUSTRY

The chemical Industry and ICI in particular were still thriving in Runcorn and providing good employment prospects. ICI were very well regarded in the town and generations of families wanted to work for the company. In 1971 there were first indications that Wigg may close. Acid production continued while a new 250,000-tonne plant was built at Rocksavage. In 1973 Wigg Works finally closed and workers were dispersed to other sites or made redundant.

Wigg Works' Dave Forsyth remembers:

I worked at ICI from 1963 until my retirement. I left school and was on the dole for eighteen months. I was desperate to get an apprenticeship. My father would throw me out every morning at 7 a.m. to get a job. I wanted to be a draughtsman. My father said 'you are not going down the pit. I received 17/6 a week on the dole. I was told at the dole office

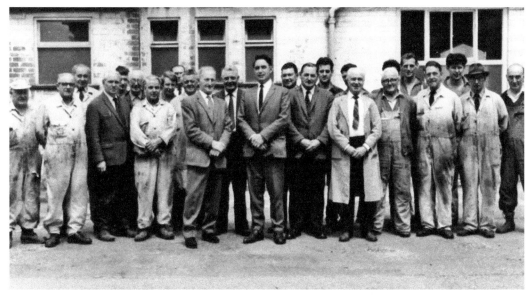

Staff at Wigg's.

Cooper's shop, Wigg's.

that ICI only took grammar school boys. I picked up the form anyway. I was worried that I had no chance if I did not have relatives at ICI. This was proved wrong as I was offered a job as a fitter. I loved every minute of it. I worked at Wigg's and Rocksavage. Wigg's was a very dirty noisy plan. It was 200 years out of date, but there was great comradeship and sense of community, lots of families – fathers, sons, brothers and uncles. I was often confused as many men had the same name – hello Mr Fish, hello Mr Fish; they were all the same family. ICI believed if your dad worked there, you had to behave yourself.

Billy Spann's memories:

I started in 1963, the same time as Dave. My brother worked there. I agree with Dave; the camaraderie was fantastic. It was a pleasure to go to work. I started at Rocksavage. When I went to Wigg Works I was surprised to see a man moving chemicals wearing only a muslin cloth around his head to protect him – and he was smoking a pipe! I thought that I had gone back to working practices of 200 years ago. During the war mustard gas was made at the lower works at the 'hush hush' factory – it was not really secret as 3,500 workers from all over the region worked there. How could it be hush hush? About 1967 the Territorial Army were called in to clear the site. There was a loud bang and thick chemicals streamed down, but when we went outside the buildings were still standing. The explosion did, however, blow out the windows of the new houses being built in the new town. They had to bring in the real army to finish the job.

As we were by the Manchester Ship Canal when we had lunch we would sit on the edge and watch the ships going to Canada, America and even little tramp ships from Germany and Sweden. If you were lucky they may be carrying fruit and vegetables and they would throw them to you. We heard that a submarine was coming down the canal. As we looked out we were astonished – the conning tower was 30 feet above us. We did not realise that a submarine could be so huge.

Wigg's workers would help anyone. If you were struggling everyone would help, bosses as well. But Rocksavage was different. It was larger, impersonal and not as friendly. There were lots of sports clubs and lots of professional rugby players and cricket umpires, darts – lots of sport – and I have still got a bowls trophy at home. Wigg's was full of characters. John Craven Hyde (Jack) would work all hours and the company looked after him. He would come in any day if a job needed doing. He used to drop his P60 on the floor so that fitters would see how much he earned and say 'been to college have you?' The fitter (Keith) went berserk. Jack claimed the extra half day travelling if you were going abroad on holiday. He was going out in his Morris Minor when the works engineer, K. M. Johnson, asked 'Where are you going?' 'On holiday' he said. 'Enjoy yourself, where are you going?' 'Rhyl'. An extra half day claimed to go to Rhyl!

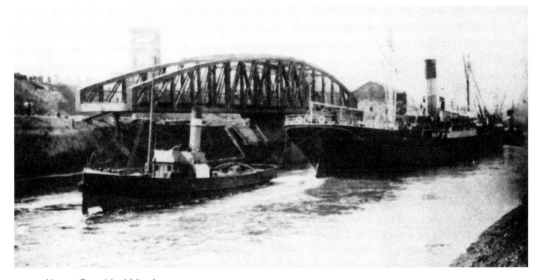

Above: Canal by Wigg's.

Below: Canal today.

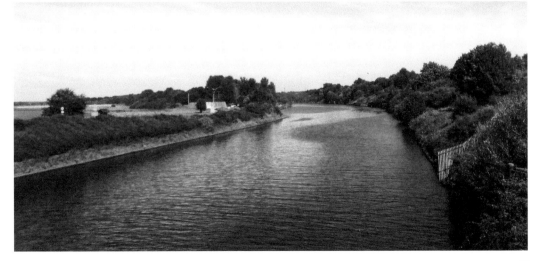

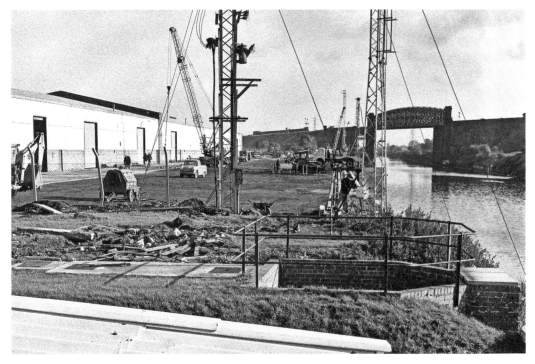

Swing bridge. (© aaronphotoarchive.org)

Tommy Durkin's memories of Castner Kellner:

> I started work in 1972 in the carbon shop and I stayed thirty-two years. From there I went on shift work filling drums tankers and ships with liquid chlorine. I then went to the manufacturing plant and stayed there until I finished. It is very dangerous work. It was a major hazard plant. Very often there were leaks and you would end up in ambulance room all night. You wore protective gear but still had to deal with lots of emergencies. I enjoyed working there and made good friends. Despite accidents there was only one fatality in all my years at Castner.
>
> There were lots of inter-works competitions – snooker, pool and darts – lots of banter and good fun. We would go to the Rec up in Widnes; we would take taxis home. It was very male orientated – no women on the plants. I was asked if I wanted early retirement aged fifty-four years. After some thought I took it. I finished at the end of December. I had a month off but got bored and I got another job at Jim Barkers in Widnes and then moved to Widnes Learning Centre.

It was great boost to the town when Runcorn Heath was chosen to house the ICI's new headquarters in 1959. The plan was to build fine offices giving technical support, and research and development facilities, as well as support for chemical plant design. The company had been working in huts built in 1938.

The buildings consisted of a service block, an administration wing and two drawing office wings. Visitors entered by an impressive entrance hall with panelled walls and stone paved floor. Runcorn's industrial life was now dominated by ICI who remained the largest single employer with around 6,500 people at Weston and The Heath in the 1970s. In 1973 the new Hydrogen Fluoride plant at Rocksavage increased production capacity by two-thirds.

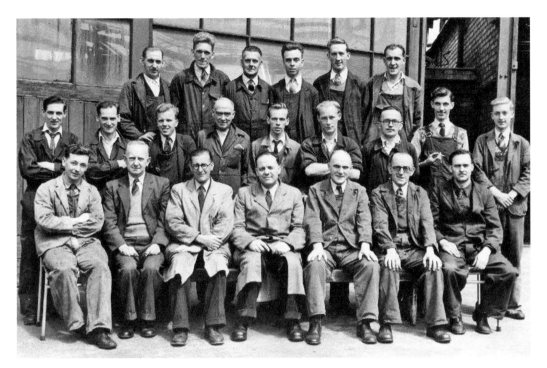

Above: Castner staff, 1950s.

Below: Castner staff, 1959.

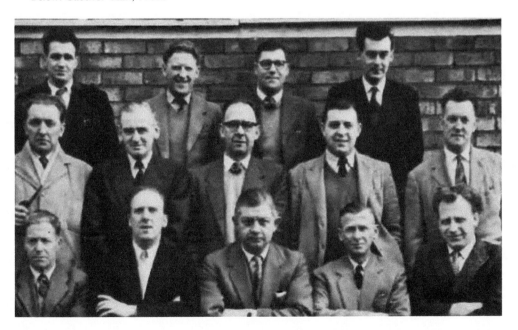

astner-Kellner Estimators, back row: T. Taylor, B. L. Jolley, J. E. Grounds, G. Lloyd; *iddle row:* R. N. Minnery, H. Stott, F. G. Booth, A. I. Harland, W. Findlow; *front row:* G. H. Jarvis, W. Adams, W. E. Davies, D. Hague, G. I. Degrave. CK8334

RUNCORN HEATH OFFICES

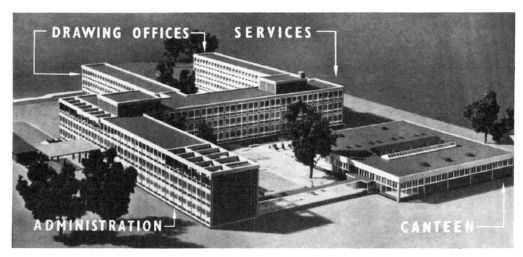

DRAWING OFFICES — SERVICES
ADMINISTRATION CANTEEN

This model of the new offices was made before construction started, but it gives a good idea of the general layout of the building.

Above: The Heath Model, 1959.

Below: Chlorine tank, Weston.

Kathy Schofield's memories of ICI:

I started at The Heath in 1971 in the R&D department aged sixteen, and I stayed for eighteen years. I had five job offers in the chemical industry but dad said 'Go to ICI as they gave shares.' It was good advice! I never regretted it. There were sixteen lab assistants started but only five were women. There was a six-week induction. We moved around

all the areas but I noticed that girls ended up in the analytical department. I insisted I wanted to work in research. I worked in block seven, on the second floor. We did wear lab coats but did not have to wear safety glasses. We would make tea and coffee in the lab and I ended up in the medical centre with caffeine poisoning. There were wonderful facilities for staff with excellent medical and dental services on the premises.

I remember the three-day week. We were fine as we had our own generator. There were very few women but the men gave me good advice about mortgages, etc. The salary was good and I was soon earning more than my father.

When I married I was offered a three-bed house in Runcorn to keep me at ICI but we managed to buy our own house in in 1977 – it cost £7,500. I left for childcare reasons and when I considered going back The Heath was shrinking and many of the lab jobs moved to Macclesfield, so I never went back.

Liz Cullen remembers:

I joined ICI as Liz Dickinson in 1972 and started work in the analytical department. I achieved my ONC with another company but wanted to work at ICI as this was the place if you wanted a career in science. It was an honour to work at ICI and I spent two years in X-ray diffraction. However I always wanted to work on the chemical plants and I requested a transfer to the radio isotope applications unit but ICI considered this no job for a woman. Women could not do the job and no female had ever done the job. I persisted and eventually they agreed to give me a day's trial. They sent me to the cell rooms in Castner Kellner. I had to wear a boiler suit, steel toe cap boots, a donkey jacket, and a helmet and carry lead bricks in my pocket to shield the radio isotopes and a breathing mask as well. The intention was to put me off completely. They did not succeed. I thought it was fantastic and they had to give me the transfer. I really enjoyed it; it was my best time at ICI.

At the time I was doing day release at Liverpool Polytechnic to achieve my GRSC (Graduate of the Royal Society of Chemistry). Here I met Kathy Schofield. I passed my Part 1 and was delighted but I was enjoying my work so much I asked to defer as did not want to leave to do my Part 2 full time. ICI agreed to this. We worked at all the chemical plants in the North West: Castner, Rocksavage and in Widnes. It was unique positon as I was the only woman working in the plants. Later there was an article in ICI Magazine claiming another woman was the first but I have no doubt I had that honour. It was a very male-dominated environment. There were no ladies toilets and no locks on the doors. A colleague would have to stand outside to guard the door. I wore protective clothing and it was not obvious that I was female. Men were often embarrassed to discover that I was a woman and if I walked in and they were swearing they would blush when they realised. I was however accepted as an equal when they realised I could do the job. We would travel to the plants in a mobile laboratory. The gatekeeper once refused me admission as he thought that the driver was bringing a girlfriend into the works. I met my husband on radio isotopes, which was great. I then went back to college to complete my GRSC. ICI kept my job for me. I went to work in the labs at The Heath working on the chemistry of phosgene. Here I was delighted to meet met Kathy again. She introduced me to the fantastic social life. There were lots of activities at lunchtime – playing tennis and running. By this time I was a cub leader explaining science to the young people. I decided to teach chemistry. I could not have done this without the support and my experience working at ICI.

Stephen Hodgson's memories of ICI and Ineos Chlorvinyls:

I was born in Liverpool and moved to Widnes in 1964 and went to school at Our Lady's, then Wade Deacon and then Halton Tech. I got a job in Runcorn at ICI's Castner Kellner site in the laboratory. The main product was chlorine gas in those early days. Health & Safety was very lax but now things are very different. To clear the chlorine the men used to go to the Weaver Pub. They would buy a pint and on the bar there would be a bowl of iced water and some butter. They dropped butter into beer and drank it down. It does not sound nice but it was very good for the throat. I never tried it but it must have worked. ICI had 3,500 workers now at Ineos Chlorovynils; it is only around 800 workers, maybe less. There was one accident I always remembered. Little Bert was using a nitrogen hose to blow water out of tank. As he was small he leaned in and was knocked out and sadly he died. I had only been there for three months. It was a real eye opener to the dangers. This accident changed health and safety systems for the better. All tanks are now clearly marked NO ENTRY. I have never forgotten the tragic incident even though it was thirty years ago. In 1979 there were lots of jobs for chemists in the local papers. It was a job for life. It was always a happy working atmosphere – there were no major issues. I played golf with my boss. At first I worked shifts but it became difficult when the family arrived and I changed to days, and I have been working days for twenty-nine years.

The Manchester Ship Canal was booming after the war. One cannot underestimate the importance of the Manchester Ship Canal in the history of Runcorn. By 1959 cargo was 18.5 million tons. Work was plentiful for the crews of the Runcorn-based tugboats and there was plenty of employment in the ship canal workshops. Divers were essential in maintaining the locks to ensure the movement of shipping.

Frank Brown explains the dangers of diving in the MSC and the heavy equipment that he was trained to use:

I started at the Manchester Ship Canal in July 1965. I left school on the Friday and started work at 6 am on the Monday morning. I was a cabin lad on a tug. I did everything – cooking, scrubbing and making beds for the captain and the mates. About two years later when I was eighteen my dad, who was a diver, asked me if I wanted to be a diver. My mum said no, stay as you are, but like many children I wanted to work with my dad.

I trained with the Liverpool and Glasgow Salvage Company in Liverpool. The training included all aspects of diving. I had to wear a big brass helmet, a diving suit and large boots. All in it weighed 155 pounds. I was very thin and scrawny and I could not stand up it was too heavy for me. I then went to the lightweight gear. This was nicknamed 'one breath from death' because it was just a mask, a rubber suit and weights to send you down. You took one breath and exhale, but if there was no air in the tank. It only happened to me once and thankfully the men up top realised and pulled me up fast coughing and spluttering. Luckily I was not very deep. I then got weightier and could wear the traditional gear. I was surprised that when you were in the water the 155 pounds felt like 10 pounds. On the bottom you can regulate your air and it was very comfortable. It was Seibe Gorman equipment. Under the water there was a lot of danger but if you had good team topside, as I did, you felt safe. We had radio contact every couple minutes and if it failed we could give signals on the diving line – two sharp pulls meant bring me up quick and one meant are you okay? New regulations meant the end of this equipment. We had to have a four-man team with a back-up standby. One diver in the water and one

standing by, a comms man and a lines man. These are still the rules today. We moved to Italian gear which was much lighter and again still used today. I was employed at MSC but we were contracted to firms around the country. My first job was to check the lock gates. There was zero visibility. When I got on the bottom I realised an old oil drum was obstructing the gates. Up top the linesman is watching your bubbles. I soon freed it and was pulled to the surface. By now MSC equipment was getting old and although it was still working, it needed constant upkeep. It was tidal working at Eastham Locks drilling under the water for new anchors. The drills were very efficient and we moved tons of granite.

There were no diving tragedies as the topside team were spot on. One terrible tragedy was recovering a small boy's body from the canal at Castlefield. He jumped into the canal and knocked himself out. His little friend tried to save him but to no avail. What a tragedy for his parents.

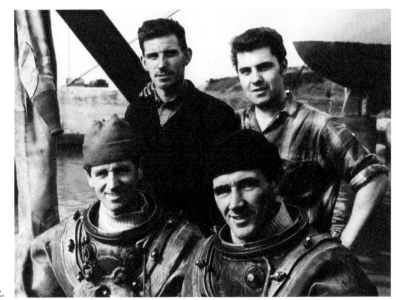

MSC divers. Frank's dad, Bill Brown, is on the left and his Uncle Les is on the right.

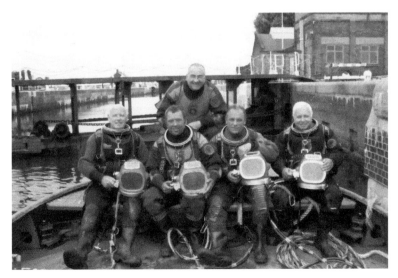

Frank standing at the rear.

Roy Gough's early canal memories, the Co-op butchers and Crosville buses:

I was born in Runcorn in 1936. I went to Holy Trinity School. My father, grandfather and grandmother worked on the boats on the Leeds and Liverpool Canal before they moved to Runcorn. They worked for Richard Ables, Bates and then the Mersey Dock and Harbour Board. One occasion we spent the night in Liverpool Dock and then came up through the Bridgewater locks and moved up to Preston Brook, where we arrived and offloaded aluminium ingots, which were transhipped down to Birmingham and Wolverhampton. One day we were on the barge on the canal by Halton Road. Uncle Jim Moores was leading the horse on the towpath. I was a young lad sitting on the hatches.

A man called to Jack my father and then threw a red Oxo tin onto the boat. Dad picked it up – it contained half-crowns – then threw him a coil of rope. It was extra five bob for dad. I had no idea where it came from!

I left school in 1951, and started work in in August in the pork department of the Co-op in Public Hall Street. They supplied all the other butcher's shops. Everything was made on the premises: pork sausages, cooked meats, black puddings … everything; they even cured their own bacon. It was a long day starting at 6 am and finishing at 5 pm. I made some good friends. I worked with Frank Jones and Les Barker. He opened his own shop opposite Littlemore's bakery in Bridge Street. I was appointed manager and left in 1962 as I had a mortgage and a growing family. I needed better wages.

A lot of butchers had left. Some workers had gone to Golden Wonder Crisps but many workers had gone to Crosville and I decided this was a good idea. It was the best job I ever had. I had two weeks' training and then I was out on the road.

My first route was to Liverpool. I did not know the area and when I was asked for a stop I had not a clue. I just hoped they would stand up and I would press the bell. My favourite was the J9 service – Halton Stockham Lane to Weston Point, an hourly service. I really

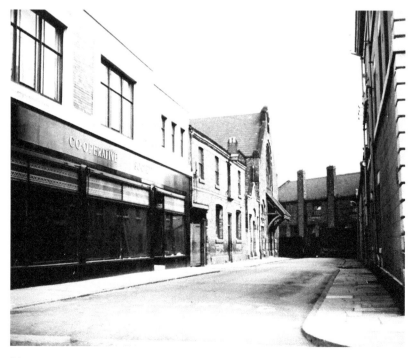

The Co-op, Public Hall Street.

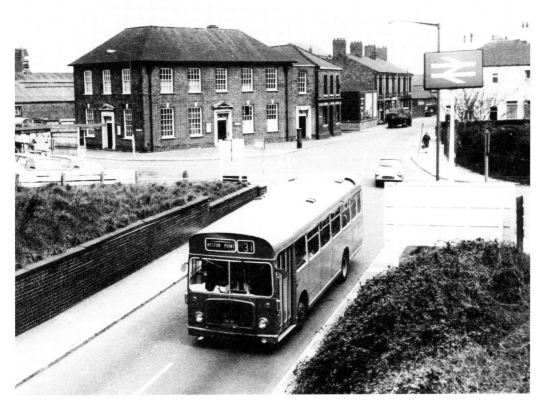

Above: Crosville bus to Weston Point.

Below: Buses on Crosville Garage.

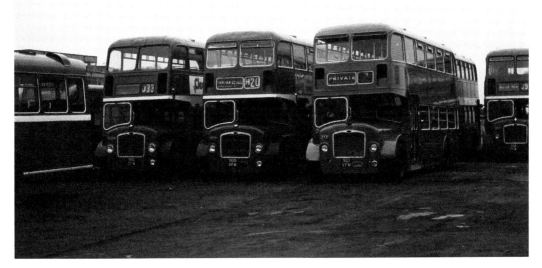

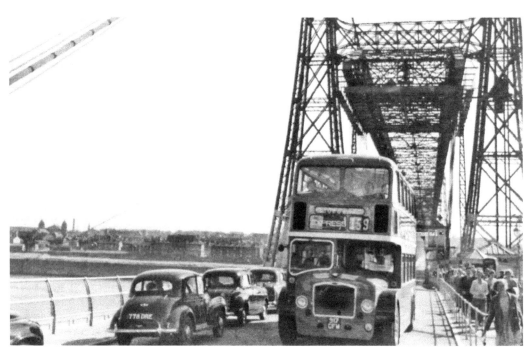

The Saturday Wales express.

enjoyed that route. There were some very busy routes – J5 Union Street to Weston Point. It was a wonderful job. On Saturdays there was extra work and overtime. I really enjoyed the Pwllheli trips. We went out about 8.00 and back at 8.30 in the evenings. We received twenty-four hours pay. We picked up the passengers at Liverpool Pier Head; they all had pre-booked tickets. I sat down and settled back to enjoy the trip. The first stop was Connahs Quay where we went in for cup of tea. I became familiar with the route and I would give a running commentary. They went to one-man manning and I did not want to drive, so I went back to being a butcher. I went to Ken Williams in Greenway Road and lasted nineteen years. When he retired I went to Doris Coles in Church Street, formally Hamnetts. I then went to Kwik Save. It was the worst place ever! I worked in a poky little room, with a fridge, a block and 92 degrees of heat. When they sold out I thought I deserved a rest but no, the next day Ron Sherwin rang and offered me a job. I stayed until 2001. I suffered a heart attack but I was sixty-five and ready to retire. That's my life in a nutshell!

In 1962 the famous line of locks in Runcorn were filled in and access to the sea was gone.

The area has now been landscaped. Commercial traffic was disappearing by the 1970s, but it was thriving as a leisure canal. Preston Brook, which had been a hub of trade on the Bridgewater and on the Trent and Mersey, was now becoming a leisure canal.

In 1974 Runcorn Urban District Council was merged with the Borough of Widnes to form the Borough of Halton and Runcorn lost its own municipal identity. This was a controversial decision as Runcorn had always looked to Cheshire for its identity. John Whitaker recalls his work at Halton Borough Council:

I have been the mayor's attendant since 1991. I actually started with the local authority in 1972 at the bus garage. In 1977 I was asked would I like to chauffeur the mayor in a

Coat of Arms

of the

Runcorn Urban District

(Granted 1956)

Or on a base barry wavy of four Azure and Argent a lymphad proper flying flags and pennon of St. George the sail also Azure charged with a garb Gold on a chief Gules two flaying-knives in saltire proper handles Or between as many fountains.

Out of a mural crown Gules a demi-lion Sable crowned with an ancient crown and supporting an abbot's crozier Or pendant therefrom by the guige an escutcheon also Gules charged with four fusils conjoined in pak each fessewise Gold.

"To fill the ship with goods"

Runcorn coat of arms.

nice Rolls-Royce. In September 1980 I went full time. My first mayor was a lady and she was very nice and we had lots of fun. The Rolls never broke down but we lost it in 1984; we ended up with a Ford Granada. We had a great trip to London. We stayed at The Bloomsbury Crest, which was a lovely hotel but it was a drive to the venue. Every mayor from every town mentioned in the Domesday Book was invited. We went to Westminster Abbey and there was a grand parade of 200 red-robed mayors crossing the road. It was quite a sight – not a policeman in site! The early nineties brought lots of changes – three departments in twelve months – and it was very unsettling. We had a mayor who worked in the cell rooms at ICI and he said his reactions were slow. When I caught his foot in the car door I said 'oh must be your slow reactions'. That was the end of it.

I once lost the mayor's badge. We had come back from Crewe and I took the chain off the mayoress and realised the badge was missing. My first reaction was it was in the car. Not there, so I thought I would have to go straight back to Crewe. Luckily she found it had fallen down her dress. It was cured with a rubber band, to stop it falling off.

The badge was once dipped in the soup – lots of laughs. Once at Runcorn town hall the mayor got lost. At my first ceremonial in the council chamber I was dressed in the tails and uniform. I put the mace down and a councillor said very loudly 'who dressed him tonight?'.

We went up to Scotland occasionally to Barry Buddon, an army cadet camp. On these trips all the local mayors went and we stayed for one night. All the drivers met at Tebay. On the M74 speeding on the motorway we were caught by a police camera on a bridge. He turned the camera away and he let it pass. We were at a remembrance service at Belle Vue Manchester. After the proceedings the attendants were shown into a room and very impressed to see a magnificent buffet where they tucked into the mayor's food by mistake. I enjoyed my time on the buses but working for the mayors has been a very good time.

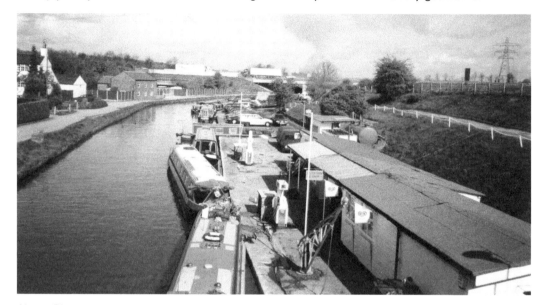

Above: Claymore.

Below: Old No 1.

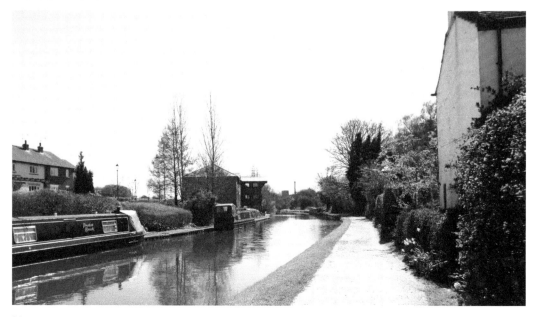

Margaret and Philip Dowling took a great risk when they decided to make their life on the canal.

We left Ulverston in January 1978. We sold our house and bought an old wooden boat in Manchester and moved to Runcorn to do it up. The children were staying with my mother- in-law. After a fortnight we moved to Dutton and the next morning we were frozen in for some weeks. We had to go to Claymore Navigation at Preston Brook to collect water and they offered us a job. That was the start. We took work at Preston Brook. It was on general cleaning and painting. We intended moving on but here we are, still here after thirty-four years.

Runcorn was an unemployment black spot. We worked for £17 a week. Luckily, we had low outgoings. We stayed at Claymore for fifteen months and then we moved to Dutton. Both of us were jobbing for various boat firms including Boat and Butty Co. and Holiday Cruise Co. We enjoyed the life it was great fun.

We worked with Peter Shrubsall, known as Shrubby. He ran a boatyard in Runcorn. He specialised in church outings and camping trips using ex-working boats – *St Austell* and *Charlotte* built by Ronnie Turner. Shrubby was a Londoner; he called everyone vicar. He was worldly wise. He claimed to have been in the 6th Airborne Parachute Regiment and he was very good humoured. He ran the Boat and Butty. It was on the site of the old tanneries in Halton Road. He had been a record producer in London. His business partner was called Marion they were chalk and cheese. She was a very quiet lady and he was the opposite.

We worked for him for four years until his death in around 1985. We also worked for a Dorset man – Peter Froud. He had three pairs of ex-working narrow powerboats – working as floating hotels. He was another colourful character. We had great fun. He was a steam engine enthusiast. We both enjoyed tinkering with buses and steam engines. He had the old Crosville bus depot; it is now the site of the Brindley. Pity the money was bad. We also enjoyed meeting the hippy commune in Dutton. Later we moved to Little Leigh and ran a hire fleet for twenty-eight years. We have no regrets. It was a great life but never any money in it. We are now retired but we will never leave the water.

Richard Monks tells the story of his family's famous grocer's shop:

My great-grandfather started the business in 1884. We now have had 126 successful years. His first shops were in Warrington. My grandfather opened a small shop in Runcorn in early 1818. We are not sure where that was, but he then moved to larger premises at 51–53 Bridge Street opposite the police station. He later opened a branch shop in Greenway Road, a flourishing wholesale and retail business. I have happy memories of my father's shop and we stayed there until it was pulled down when the Shopping City opened. It was a big shop double-fronted with the doors open to keep the provisions cold. I would be picked up from school by the delivery driver and taken back to the shop. I loved to stack shelves until 6 o'clock. I had my own corner covering soup, tinned vegetables, Twining teas and Tiptree's jam. I loved it but I was not allowed near the cheese or the bacon. On the way home from school provisions were delivered all over as far as Dutton and even Acton Bridge. We were in a Morris Minor van; there was no front seat. I would sit on an orange crate. I always had orange stains on my trousers. There were no seat belts and if we wanted to indicate I had to knock on the door to make them pop out. It was a fine van. We painted it cream and blue with fine lettering.

When I was ten my father was forced to leave shop as it was demolished. He was sad to move to the Shopping City but he had no option. He was offered a much smaller unit – it was 12 ft. square. He had to sell his equipment as everything had to be new. We skipped the lot. He was never adequately compensated by Development Corporation. My dad made the best of it, as he always did, and we were busy for first few years. With the arrival of Tesco and the yearly rent increases we started to struggle and dad planned to retire. He knew that my best bet if I wanted to continue the business was to move back to Runcorn. My mother wanted me to go to university and never wanted me to leave school at fifteen, but I wanted to follow my father into the shop. I never regretted it – not the best pay but I enjoy it. A new shop was found near market hall and we started to move back into a high-class deli. We moved to this shop in 2005. Sadly my father never saw my new shop, the old Littlemore's shop in Granville Street, but he would have been very proud to see the queues to the door on Friday and Saturday. It is still thriving today due to my loyal customers and excellent staff.

Monks delicatessen today.

The new market hall.

Maurice Littlemore remembers the family's baker's shops:

I was born in 1931 and went to work for my father aged fifteen in the bakery and confectioner's business. It was started in 1914 in Heath Road by my Uncle Joe. My father joined when he was demobbed after the First World War in 1919. The business moved to Church Street in 1920 and later opened three more shops: Greenway Road, Bridge Street and Baker Road in Weston.

I remember I earned about 4p an hour wages – low but in those days we paid £4,100 for a semi-detached house. We were happy to work in the family firm with my brother and sister and when my mum and dad died, we took over. I enjoyed the baking but not the government paperwork and all the form filling. We were in competition with the Devonshire but we made the best pies. We also made bread, wedding cakes, eccles cakes and Swiss roll. I am still stopped to this day and asked to bake a pie. Experience told us how much to bake each day. We baked on the premises and very fresh. I was sixty-eight when I retired; my sister was younger, so we stayed on and all finished together.

Littlemore's.

THE NEW TOWN

The decision, in 1964, to designate Runcorn as a New Town was to change the town forever.

There is no doubt that proposals for new towns were made with the intention to provide better housing and future prosperity, but there are other consequences. Many of the long-term residents have not welcomed the developments and many still dislike their beloved town now being known as 'the old town'. Thirty-seven farms on green fields around the town would disappear. Ambitious plans included a town park, a fine new library and a new hospital.

The new town welcomed 33,500 newcomers and by 1979, 10,068 houses for rent had been built. The plan was to build very modern homes but estates such as Southgate were not a success and were unpopular with residents. They were demolished by 1992 and replaced by

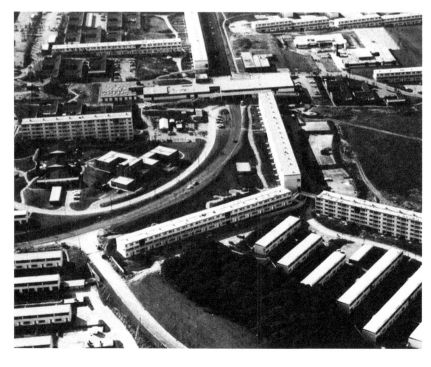

Castlefields.

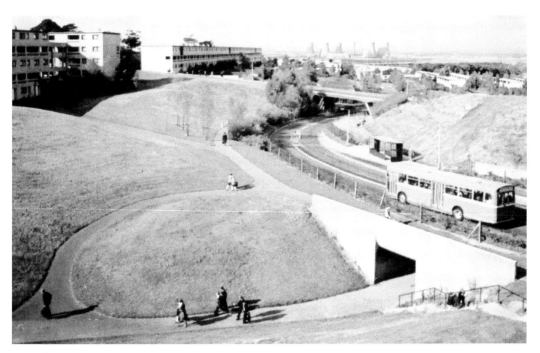

Busway.

traditional designs. There were also modern transport ideas. In 1971 the Busway, Runcorn's rapid transit system, was opened, bringing shoppers to the 'Shopping City'.

The shopping centre was influenced by the American shopping malls and although the Busway provided public transport links, the provision of a large number of free car parking spaces made the car the king.

The centre was to be the centrepiece of Runcorn New Town. It was something new and at first it was very successful and attracted large numbers of shoppers. The Shopping City later suffered when landlords increased rents and units closed.

This early success sadly resulted in loss of retail trade in the old town and demolition caused many of the shops in Runcorn to close down. The government also aimed to bring employment to these many newcomers and by the early 1970s two major industrial estates at Astmoor and Whitehouse were completed.

In 1974 Bass opened a prestige mega brewery at the Whitehouse Industrial Estate. At one time it was the largest brewery in Europe. It was an ideal site, with easy access to the motorway network and a good supply of water direct from Lake Vyrnwy. The New Town provided the workforce and also good-quality housing. They produced the country's most popular beers including Carling Black Label, Stones Best Bitter and Tennent's Lager. It was planned as the most modern brewery using new quality assurance equipment and the high-speed packaging lines epitomised all that was best in modern technology.

This aim to modernise and use new equipment did however result in technical problems. The company was also plagued by industrial unrest. Sadly, the brewery ceased production and closed down in 1991 with the loss of some 400 jobs.

The Guinness ships, *Lady Grania* and *Lady Gwendolen*, were familiar sites on the ship canal transporting Guinness from Dublin to the bottling centre in Manchester. In the early 1970s they opened a distribution centre nearby at Whitehouse Industrial Estate.

New Town house garages.

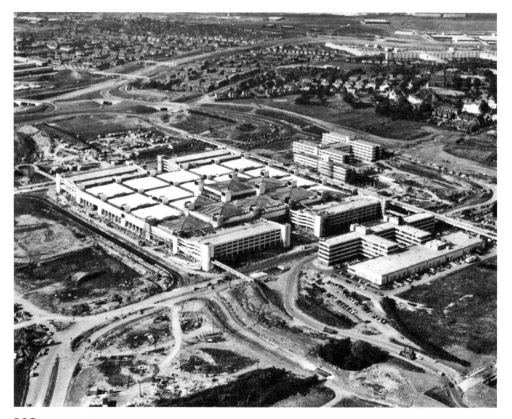

RSC construction.

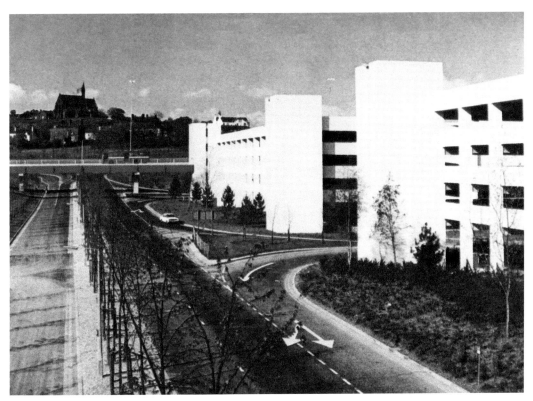

Above and below: Runcorn Shopping City.

Above: Dorrister's
(© aaronphotoarchive.org)

Left: Calvert's.
(© aaronphotoarchive.org)

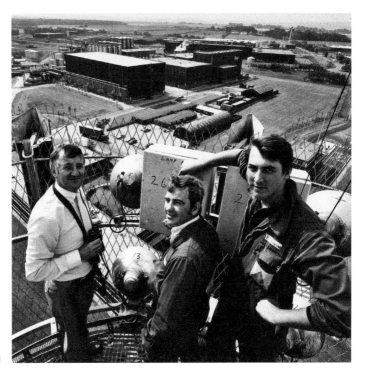

Bass Tower. A birds-eye
view for PR manager
Norman Froggatt
with two engineers.
(© aaronphotoarchive.org)

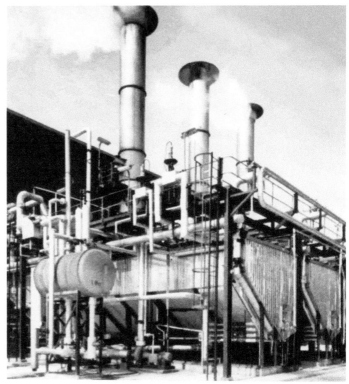

Mid-way through the brewing process: the three wort coppers.

Bass.

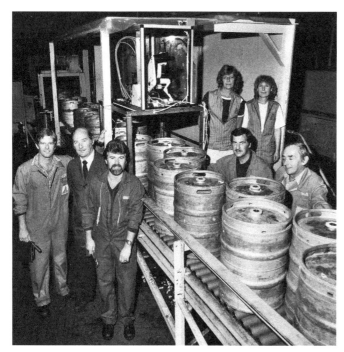

Left: Dave Linford
with his kegging team.
(© aaronphotoarchive.org)

Below: Dennis Law,
footballing legend,
promoting Tennants lager
with Peter Rowlands, Wes
Brown, Fred?, Billy Marshall
and Charlie Lloyd.
(© aaronphotoarchive.org)

In the 1980s the number employed in the chemical industry began to decline rapidly, and ICI sold its factories in Runcorn to INEOS. The main laboratory and offices at The Heath were sold off and it is now a successful business park. ICI's traditional skills base has been retained and now around 1,700 are employed there. The Heath has over 150 companies from more than twenty different business sectors operating on a daily basis, providing high-quality office and laboratory accommodation

INOVYN is working in partnership with Halton Borough Council to develop and deliver the Rocksavage International Project, a new and distinct facility on the main Runcorn site that will be attractive to advanced manufacturing and semi-tech companies, companies with high power

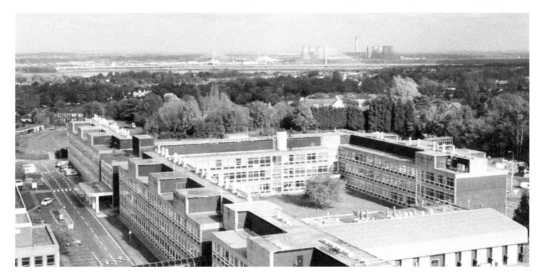

Above: The Heath.

Below: Ineos.

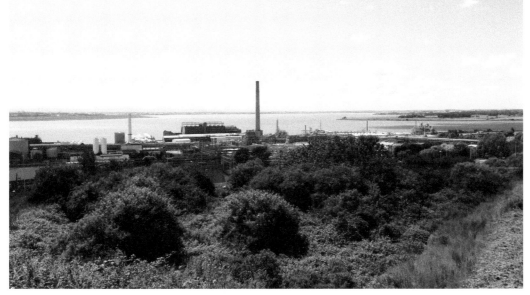

demands and chemical-related activities that would benefit from access to INOVYN's downstream products and on-site facilities. It is also considering a number of projects to support the region's desire to put the north-west of England at the forefront of the UK's hydrogen journey.

DARESBURY

Another success story is Daresbury Laboratory, renowned for its world-leading scientific research. The laboratory began operations in 1962 and was officially opened on 16 June 1967 as the Daresbury Nuclear Physics Laboratory. Since then it has continued to flourish.

These days the laboratory is part of a larger campus, Sci-Tech Daresbury. With partners Langtree and Halton Borough Council the site continues to attract science and technology companies and is now home to around 140 companies. An exciting new development is Project Violet, which has been granted planning permission to build a new office complex.

Recently the Japanese technology company Hosokawa Micron announced the launch of its start-of-the-art lab facility. The company's relocation to Runcorn is part of an expansion of its testing facility and manufacturing capabilities in the UK.

Another exciting company at Sci-Tech Daresbury is Flexera Software, a leading provider of next-generation software licensing, compliance, security and installation solutions for application producers and enterprises. The company is recruiting apprentices from the local area, which is a boost to ambitious local young people.

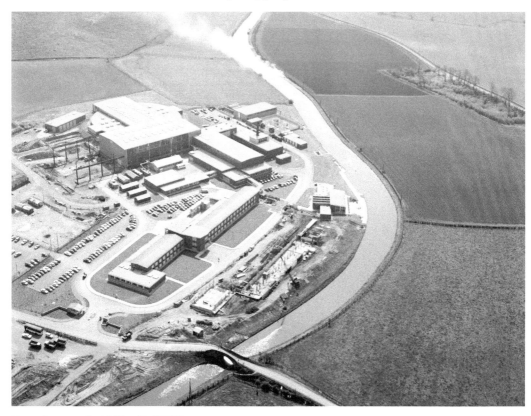

Daresbury, early 1960s. (© STFC)

Right: Daresbury. The Cray
Supercomputer at DL in 1979.
(© STFC)

Below: Aerial view of the Daresbury
site today. (© STFC)

The new Mersey Gateway Bridge was opened for traffic in November 2017, and was officially opened by HM Queen Elizabeth the following year. It cannot be denied that
the construction period did create some challenges on the local road network in both Widnes and Runcorn.

The iconic Mersey Gateway Bridge has welcomed over 23 million journeys in its first year of operation, averaging 64,000 crossings per day and 72,000 each weekday. The bridge is not without controversy. The tolls are unpopular. Transport companies are reporting that they are an administration burden and are a major cost to the freight industry. The Silver Jubilee Bridge is still closed, causing a major disruption to locals in the old town. Commercial property companies are reporting high demand in Halton, so we may be seeing benefits.

This is an account of Runcorn from a sleepy backwater to a busy thriving town. The coming of the canals transformed Runcorn. There were men of vision who started industry in the town: John Johnson, Thomas Hazlehurst, Dennis Brundrit, Harry Baker and others. They also built fine houses, many of which are still standing.

I have tried to tell the story and hear the voices of the talented and hard-working men and women that have made the town what it is today.

Mersey Gateway Construction.

ACKNOWLEDGEMENTS

We are grateful to Roy Gough for his permission to use his photographs. We must also thank Peter Blackmore and Alex Cowan of Runcorn Historical Society for their advice and support. We are grateful to Billy Hyland for his photographs and Norman Froggatt who shared his recollections of Bass brewery. Finally, my thanks to everyone who contributed to the oral histories in the Halton Heritage Partnership *Working Lives* project. Many of them are reproduced here.

ABOUT THE AUTHORS

Jean managed the local history collection in Runcorn and Widnes Library for many years. She has also created the image website for Halton – www.picturehalton.gov.uk. She has published a number of heritage walk leaflets for Halton Library Service. Now retired, she is an adult tutor, offering courses in family history.

John has numerous production credits in theatre, TV and film. Ex-BBC and Granada, he has worked mainly for the last decade in portrait, film and artscape photography. Previous publications include *Widnes Through Time*, *Central Manchester Through Time*, *A-Z of Manchester*, *Runcorn Through the Ages* and *Widnes at Work*.